This book *features all the hummingbirds found in Texas and the southwestern United States and images of hummingbirds photographed in Texas, New Mexico, Arizona, Montana, California, Mexico, and Honduras. In the first half of the book, we look at some of the ways humans interact with these tiny birds and show how, through citizen-science projects and ecotourism opportunities, everyone can enjoy their company while helping to promote their well being. We give a few key instructions on how to plant gardens to attract larger numbers to your yard and how to provide protection for hummingbirds. Then we present some information about over-wintering trends and migratory behavior. In the second half of the book, we describe nineteen species of hummingbirds and offer new range maps and abundance graphs showing where and when they occur. For each, detailed artwork shows subtle differences to aid in the identification of male and female birds.*

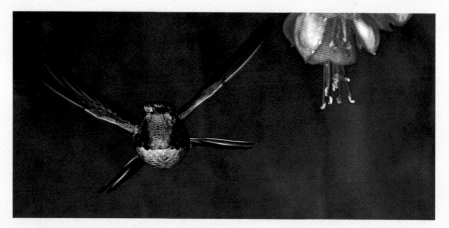

An interesting head-on view of the wings and spread tail of a male Anna's Hummingbird. The family of hummingbirds, Trochilidae, is only found in the Western Hemisphere and reaches its highest diversity in the tropics, especially along the equator. There are more than three hundred species of hummingbirds found in the Americas. Of all the hummingbirds that breed in the United States, the range of Anna's Hummingbird is the only one that does not extend south of the Tropic of Cancer.

A**T**M nature guides

Hummingbirds of Texas with Their New Mexico and Arizona Ranges

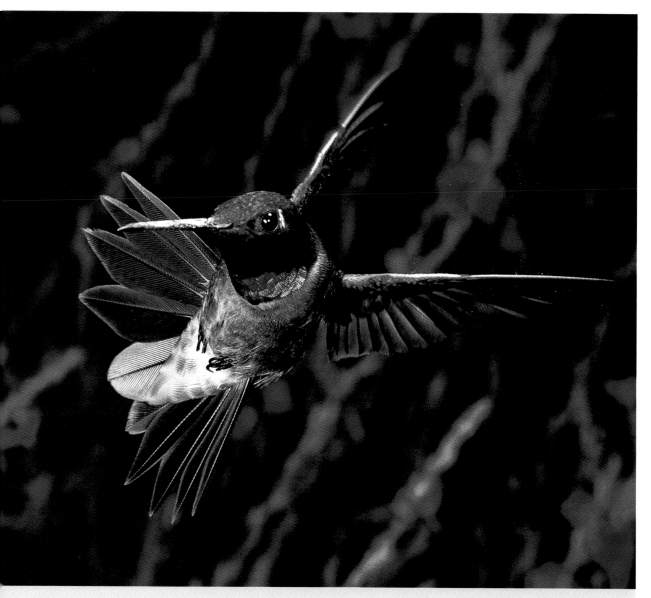

During flight, a hummingbird's heart can race at more than twelve hundred beats per minute. This male Black-chinned Hummingbird sports only a thin sliver of deep purple in the bottom half of its gorget. The upper half is a flat black, as the name indicates. The Black-chinned Hummingbird is the most familiar and ubiquitous species for the three-state area covered by this book.

Hummingbird

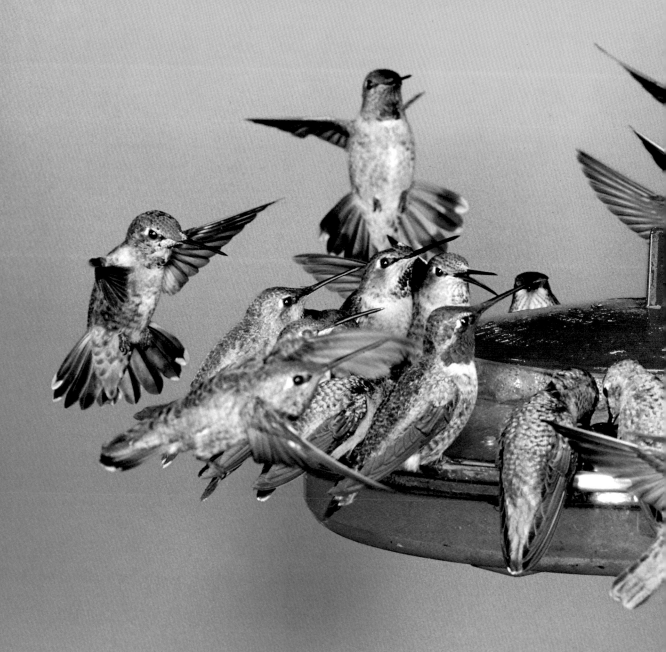

of Texas

**with Their New Mexico
and Arizona Ranges**

Clifford E. Shackelford,
Madge M. Lindsay,
and C. Mark Klym

Photographs by
Sid and Shirley Rucker
Art by Clemente Guzman III

Texas A&M University Press
College Station

The paper used in this book
meets the minimum requirements of the
American National Standard for Permanence
of Paper for Printed Library Materials,
Z39.48-1984.
Binding materials have been chosen for durability.

Library of Congress Cataloging-in-Publication Data

Shackelford, Clifford Eugene, 1967–
 Hummingbirds of Texas and their New Mexico and
Arizona ranges / Clifford E. Shackelford, Madge M.
Lindsay, and C. Mark Klym ; photographs by Sid and
Shirley Rucker ; art by Clemente Guzman III.
 p. cm.
 Includes index.
 ISBN 1-58544-433-2 (cloth : alk. paper)
 1. Hummingbirds—Texas. 2. Hummingbirds—
New Mexico. 3. Hummingbirds—Arizona.
I. Lindsay, Madge M. II. Klym, C. Mark., 1959–
III. Title.
QL696.A558H53 2005
598.7'64'09764—dc22 2004028320
ISBN-13: 978-1-60344-110-0 (pbk.)
ISBN-10: 1-60344-110-7 (pbk.)

Cover photo: Male Ruby-throated Hummingbird

Title page:
Hummingbirds do not migrate in flocks as waterfowl do, but they do
congregate at feeders during southbound migration. Included at this
single feeder are twenty-eight hummingbirds, mostly Anna's, Rufous, and
Black-chinned. Peak southbound migration in western hummingbirds is
typically in the late summer in Texas, New Mexico, and Arizona. Late July
to early August, for example, can be the best times to see events such
as this. Southbound Ruby-throated Hummingbirds in Texas, however,
usually peak in September.

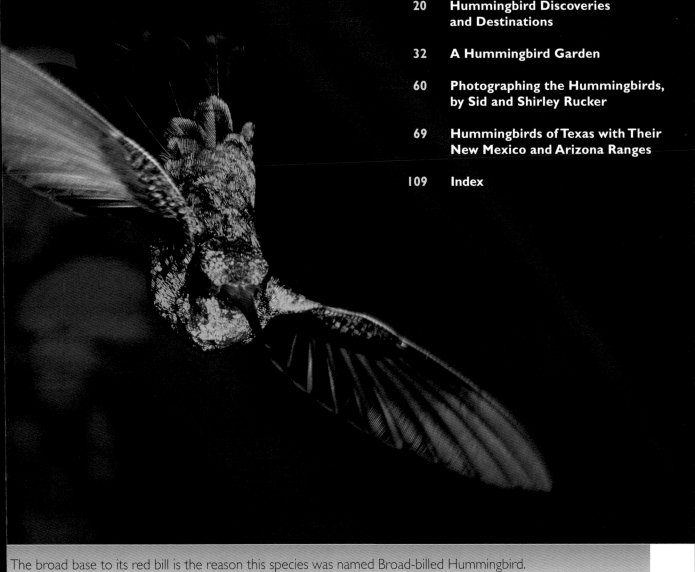

20 **Hummingbird Discoveries and Destinations**

32 **A Hummingbird Garden**

60 **Photographing the Hummingbirds, by Sid and Shirley Rucker**

69 **Hummingbirds of Texas with Their New Mexico and Arizona Ranges**

109 **Index**

The broad base to its red bill is the reason this species was named Broad-billed Hummingbird. In optimum lighting, the males of this species are the most shockingly iridescent of all the U.S. hummingbirds. The entire body can appear several different colors depending on the angle to the light, from a glittery green or blue to a dull, blacked-out look.

To our families and to all those
who enjoy and love hummingbirds

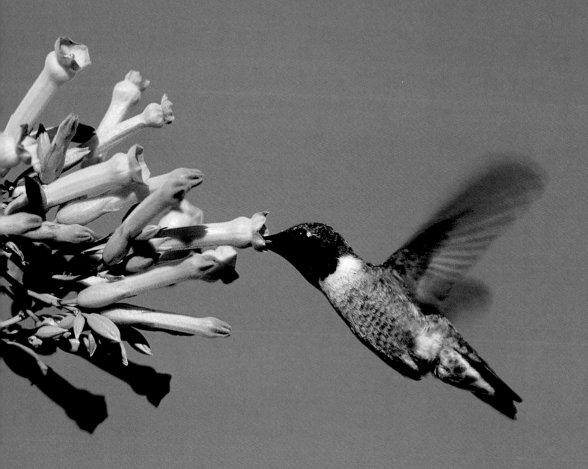

Acknowledgments

The authors wish to thank the hundreds of hummingbird watchers who reported unusual sightings and gave us new leads and a lot of information, making the Texas Hummingbird Roundup possible and also giving us the inspiration to write this book. Thanks go especially to Greg Lasley, former secretary of the Texas Bird Records Committee at the Texas Ornithological Society (TOS), who from the beginning helped with the Texas Hummingbird Roundup, developing range maps and providing other support. Also, we want to thank Mark Lockwood and Noreen Damude for their expertise in identifying birds from many photos, videos, and written sources. Mark Lockwood and Doug Altshuler provided technical guidance on the original artwork; their expertise on fine detail is much appreciated. Our thanks go to Keith Arnold at Texas A&M University, who archived photos and new county records and allowed us access to specimens in the Texas Cooperative Wildlife Collection. The photographers would like to thank the hummingbird fans who helped locate birds that were photographed for this book.

The Texas Hummingbird Roundup staff and interns—Kari Sutton, Kelly Bender, Jereme Phillips, Christina McCain, and others, who over the years helped to keep the Roundup going—receive very special thanks. An additional "thank you" goes to John Herron and Pat Morton with the Texas Parks and Wildlife Department for helping to move this project high on the priority list. We would also like to thank Terry Johnson at the Georgia Department of Natural Resources, who allowed the Texas Parks and Wildlife Department to adapt the Texas Hummingbird Roundup from Georgia's Hummingbird Helpers program. We are grateful to the many people who responded to our requests for information and would especially like to thank Russ Nelson, Steve Russell (Arizona), Christopher Rustay (New Mexico), and Jason Singhurst. Again, we would like to acknowledge Mark Lockwood, who spent a considerable amount of time assisting the authors; his expertise and willingness to share information are much appreciated. And finally, Shannon Davies and Jennifer Ann Hobson were instrumental in getting this book project completed.

Nectar-giving plants are extremely important to hummingbirds. This male Black-chinned Hummingbird is feeding on tree tobacco in South Texas. At certain angles to the light, the bright iridescent colors of the gorget can be completely blacked out. When used as a field mark, iridescence can appear to be a multicolored rainbow or even a mirage, thus playing tricks on the observer.

Foreword

Greg W. Lasley

Hummingbirds are among the most fascinating creatures in the natural world. Although some other species of birds are able to hover, none do it with the masterful ability of a hummingbird. The hummingbird's ability to fly backward is unique among birds. Combine their aerobatic prowess with their endearing behavior of visiting our back porches and gardens and you have a combination that has captured the hearts of birders and nonbirders alike. So popular has the hummingbird become that the hummingbird feeder industry has grown exponentially across the United States in recent years. There are clubs devoted to hummingbirds, state programs developed to keep track of hummingbirds and the people who feed them, and entire festivals that draw thousands of participants to towns in several states, including Texas, to learn about these magnificent flying jewels. Our thirst for knowledge about these creatures seems to be never ending, and scores of books about hummingbirds have been published in the past decade.

Texas, New Mexico, and Arizona have the greatest hummingbird populations and diversity in North America (north of Mexico). Observers flock to West Texas, New Mexico, and Arizona annually to see the kaleidoscope of colors and patterns displayed by the numerous species that pass through each year. For many years, Arizona was considered the "hot spot" in the United States for hummingbirds, but recent years have shown that West Texas in general and the Davis Mountains in particular have offered a challenge to this title. I have had the pleasure of sitting in a private yard in the Davis Mountains and watching literally a hundred or more hummingbirds of six or more species in view at once! Scenes such as this are never to be forgotten and highlight the magical allure of hummingbirds and our desire to learn more about them.

Cliff Shackelford, Madge Lindsay, and Mark Klym have combined their years of observations, knowledge, and love of hummingbirds to bring us *Hummingbirds of Texas*. Not only does this book have excellent illustrations and photographs of the species covered but the authors give a detailed synopsis of where each species occurs, including information on the distribution of the rarer species. Habitat, geographical distribution, and descriptions are all provided with a focus on the specific identification characters for each species. In addition to the detailed specific accounts of the many species covered, the book provides information about the widely popular Texas Hummingbird Roundup, a program sponsored by the Texas Parks and Wildlife Department; readers will learn how to become involved in this important annual survey. It is easy to see why this book will be an important addition to the library of anyone who is interested in hummingbirds.

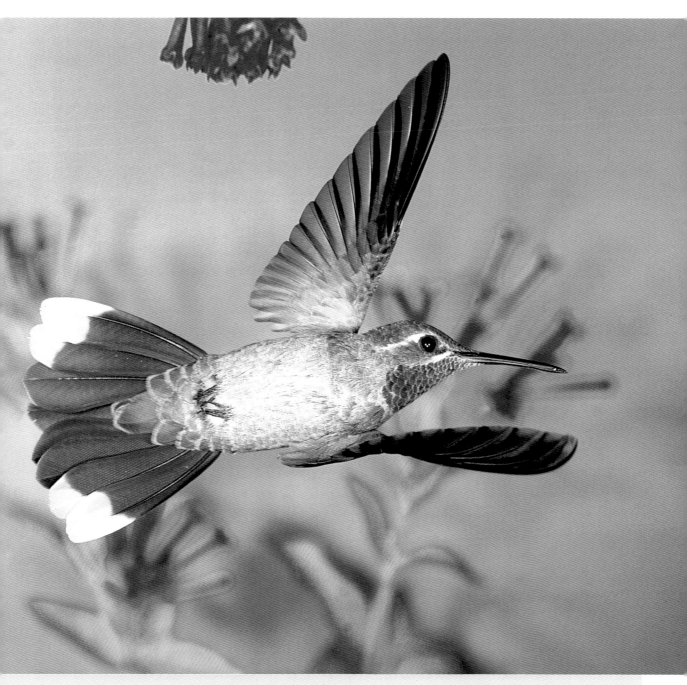

This male Blue-throated Hummingbird departs quickly by flying horizontally. At odd angles to the light, its blue throat can appear gray or scaled. Most species of hummingbirds can breed during their first spring (less than one year old) and thus obtain their bright adult plumage before their first spring.

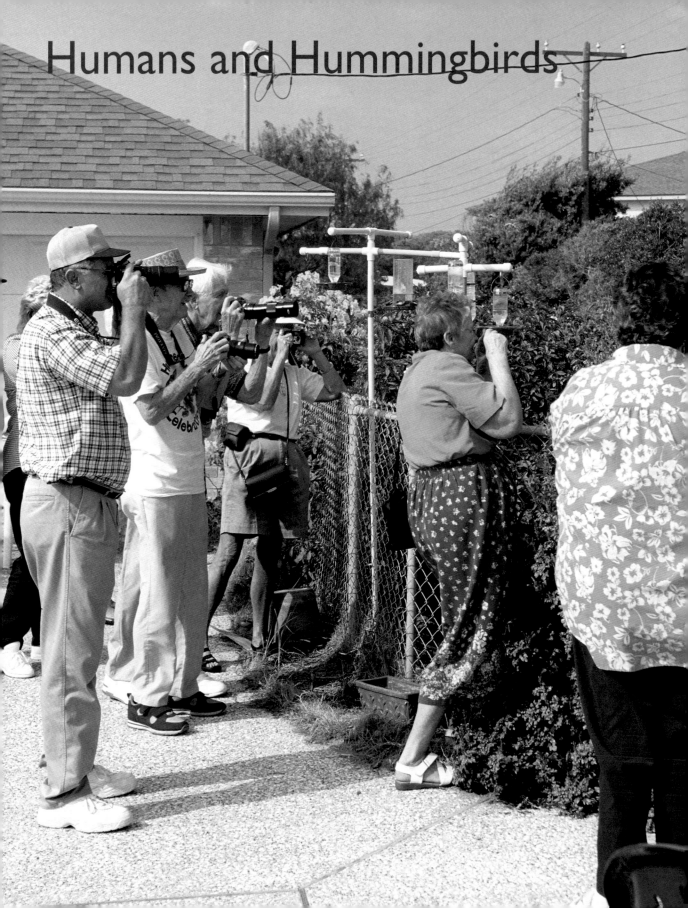

The tour of homes at Rockport's Hummer/Bird Celebration is very popular because willing residents open up their backyards and extend hospitality to visiting birders who come to view large congregations of Ruby-throated Hummingbirds. This event showcases one of the best hummingbird spectacles in the United States.

It is little wonder that most people are fascinated by, some even *in love* with, hummingbirds. With more than 70 percent of the human body's sense receptors clustered in the eyes, watching hummingbirds is natural, especially by those eyes seeking novelty and diversity. One up-close look at a hummingbird's brilliant beauty causes some watchers to become hooked for life and forever dedicated to attracting these birds into their yards. Hummingbirds are a favorite for all birdwatchers, from the most seasoned avid birder to those who only feed and watch this one species group. It is the birds' predictable penchant to return to favorite feeding areas and gardens, year after year, that has caused humans over many decades to readily respond with feeders to lure them in.

Because of the popularity of hummingbird feeding, in 1994 the Texas Parks and Wildlife Department (TPWD) encouraged hundreds of Texans to join in a citizen-science survey of gardens, backyards, and ranches across the state. The agency invited anyone who was currently feeding hummingbirds to become part of the Texas Hummingbird Roundup. Participants had to sign up with a small fee, identify their backyard hummingbirds, record the dates of their sightings, and call the TPWD if they had rare birds they could not identify. At the end of the year, they were asked to return their survey forms. The public responded enthusiastically with more than 1,220 citizens from well over half of Texas' 254 counties signing up the first year.

As the Roundup grew in popularity, more counties were surveyed and more eyes were on the birds. After only two years of citizen watching and survey responses, the TPWD staff had confirmed what many ornithologists had long suspected: Texas hosted more hummingbird species than any other U.S. state. They were also able to verify and sometimes expand distribution ranges for some species.

With citizens helping from Beaumont to Brownsville, Amarillo to El Paso, and Lajitas to Texarkana, the survey flourished. Through phone calls, postcards, and pictures, and with experts investigating rare and questionable reports, over the next five years a wealth of information was collected on this group of birds for the first time in Texas. Eighteen species were documented, and new county sightings were recorded across the state. Overwintering routines were noted. Rare bird sightings were compiled, and several new hummingbird spectacles were located and documented. Because of the survey, the Roundup team established that thousands of Texans had been feeding and enjoying hummingbirds for years. And through the Roundup, these citizens were learning more about their hummingbirds and about how to better attract and host them.

Right away it was obvious that participants had great feelings for these birds and wanted to share them, as warm, insightful letters and dutifully documented reports filled the **TPWD** mailbox starting with the first survey year. Overall, one of the survey's most compelling findings is a demonstration of great reverence, suggesting a strong emotional bond between hummingbird hosts and their tiny avian guests.

Some observers wrote detailed letters describing behavior; they sent along photos and videos of birds at feeders. Participants shared sad stories about hummingbird predators and foes; they submitted notes on rescues and about birds in torpor, as well as stories about *their birds* riding out spring and summer storms. During migration and in the breeding season, observational letters and phone calls keep Roundup staff busy.

I do believe most of my hummingbirds come back each year; even the one without the tail arrived on time. I hate to see them leave in the fall. It is like your children leaving for school. I haven't as many fighters this year; sometimes it is hard for the little ladies to eat.
McClennan County, Texas, 1994

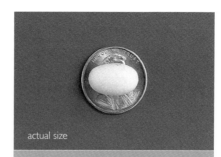

actual size

The egg of a Black-chinned Hummingbird is so tiny that it does not fully cover the bust of Abraham Lincoln on the U.S. penny. Hummingbirds, of course, lay the smallest eggs of any bird in the world. They typically lay two eggs per clutch and both commonly fledge.

This was my first year to participate in the Roundup. I can honestly say it has truly been a labor of love. It has not only been fun, but I've also learned so much. Now my neighbors come to me with questions and are also enjoying these birds.
Fort Bend County, Texas, 1995

It was apparent that participants enjoyed watching hummingbird behavior. Letters were sent describing birds bathing in water dripping from an air-conditioner or rolling on drops of mist or dew collected on leaves. Another told of a hummingbird skimming the surface of the water in the family swimming pool, and one reported watching a hummingbird sunning on a gravel path with its wings widespread. Some participants with keen eyes described nests in trees near their houses. Others wrote of some unusual places where nests were found. A photo sent to the Roundup taken in South Texas showed a hummingbird nesting on a clothesline right next to a clothespin.

My daughter had a hummingbird nest on a wind chime hanging on her porch. Two eggs laid. One hatched. She filmed the mother feeding the baby, but sadly missed when it fledged.
Denton County, Texas, 1994

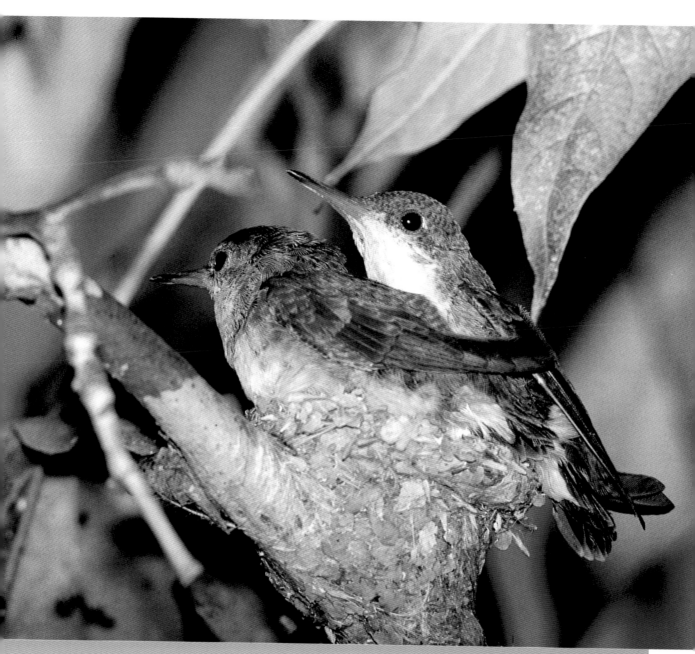

The color pattern in these growing Violet-crowned Hummingbird nestlings is already apparent but diluted and not as pronounced as in the adults. Spiders are important to adult and nestling hummingbirds in several ways. First, hummingbirds use web fibers as sticky material to hold the nest together. In addition, hummingbirds take prey items caught in the web of a spider, and they may also consume spiders and their young or eggs.

Hummingbird feeding observations were reported frequently in letters. And some people even tried feeding experiments.

They are flying back and forth and squeaking constantly in the summer months. I tried a couple of years ago to eliminate one of the feeders by not putting it out in March. But the little guard saw me at the kitchen sink and would hover at the window in front of me, then fly to the bracket where I had hung it the year before and perch on the bracket before doing the same thing again. I hung a feeder where he wanted it!

Hays County, Texas, 1995

One observer noted for more than fifteen days in December a Black-chinned Hummingbird feeding at Turk's cap and firecracker fern plants. The participant hung a feeder close to the plants, but after three days of periodic observation noted never having witnessed the bird using the feeder.

At the end of September, we had a terrific storm at night. The next morning we overslept, and when I opened my bedroom window, it was full daylight and on a wire on the front porch where the feeders hang, I saw at least two dozen or more hummingbirds, looking for all the world like a row of sparrows on a telephone line! I leaped out of bed and ran to get their feeders. They were waiting for their breakfast, and I don't think I will ever forget the sight of all those belligerent hummingbirds sitting patiently waiting for what they knew should have already been waiting for them.

Austin County, Texas, 1996

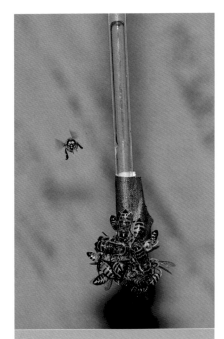

Most hummingbird enthusiasts despise bees, wasps, or ants at their feeders. These honeybees are often considered unwanted pests because they crowd the feeder in such a way that will not permit hummingbirds to pay a visit. Insecticide sprays should never be used, because the chemicals are harmful to hummingbirds. Instead, consider feeding all the nectar-seeking species by mounting additional feeders and by obtaining hummingbird feeders with bee guards.

Participants were especially astute in watching out for predators, and some were quite protective of their birds. Several observed predators preying on hummingbirds. Most common were praying mantises and garden spiders ensnaring birds. One observer noted a praying mantis that had defeathered and eaten a male Black-chinned Hummingbird. Many observers reported rescuing birds from garden-spider webs and cleaning web pieces from birds so they could fly.

I have a feeder at my kitchen window, and she (a Black-chinned) would be there every morning waiting for me. She would talk to me when the feeder was low. One morning she was chattering more than usual and would fly up to the feeder, but would not feed. That morning she hovered longer than usual and was much more vocal. I went outside and found a large house spider that overnight had built a web on part of the feeder. [After I disposed of] the spider and web, Bandit returned to her normal chatter and would perch to drink from the feeder. I was really sorry to see her leave this fall, and I hope she can find her way back again next spring.

Ector County, Texas, 1995

Contributors from Chambers County told of Loggerhead Shrikes preying on hummingbirds. The shrike would hide on the side of a feeder waiting for a bird to come in and feed. To fix the problem, they removed the perches from the back of the feeder so the shrike had no place to hide.

All these letters are inspiring, showing the great lengths to which hummingbird hosts go when watching out for their birds. Observing the birds' behavior and needs and responding with care and compassion are admirable traits of Roundup participants. But the letters that truly inspired Roundup staff were those that arrived with colorful photographs of the beautiful yards and gardens that participants were creating for their tiny guests. After all, this is one of the survey's objectives—to help Texans realize the benefits and pleasures of native backyard gardening and learn to host birds in a more natural way. There is nothing better than a native garden with all the elements of food, water, and cover to prepare dedicated watchers for next season's tiny travelers.

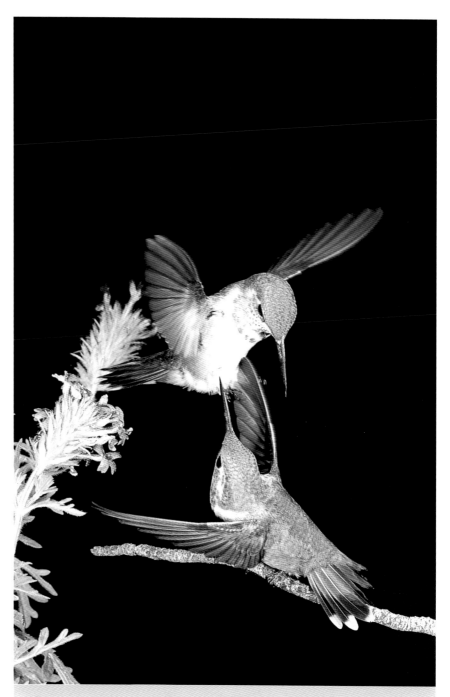

Feisty until the end, these two Rufous Hummingbirds are fighting over a commanding perch. When resting, hummingbirds typically like to perch where they have a good view of their surroundings. That way they can patrol their territory or a favorite flowering plant while also watching out for predators.

Since 1994, when the Texas Hummingbird Roundup began, more than four thousand volunteers have taken part in the survey. Although there are counties of Texas with no volunteers participating, observers have reported from all nine ecological regions of the state. Participation varies, but the average year has included more than three hundred completed and submitted surveys.

Survey return maps show that the Roundup began strong, and remains strong, in the heavily populated eastern half of the state. Harris County, which comprises metropolitan Houston, sent as many as fifty-three surveys to the program in a single year. Meanwhile, West Texas, particularly the extremely hummingbird-diverse regions west of the Pecos River, returned only thirty-three surveys for all eight (large) counties over the first five years of the program. Clearly, there is information missing in that region. To try to capture this possible missing information, TPWD has focused efforts of the Hummingbird Roundup in the West Texas area through the new Treasures of the Trans-Pecos program. Efforts to introduce educational and outreach programs are also focused on hummingbirds in this area. Orders for survey kits from the region are increasing, but it is hoped that an increase in returned surveys will soon follow.

This valuable information is stored in a database that allows TPWD to track trends in the data. The data are also made available to hummingbird researchers, especially graduate students, allowing them to know where a bird species might reliably be found.

For more information about the Texas Hummingbird Roundup, or to become involved, please visit www.tpwd.state.tx.us/nature/birding/humrunup.htm or write Texas Parks and Wildlife Department, Attn. Texas Hummingbird Roundup, 4200 Smith School Rd., Austin, TX 78744.

Licensed hummingbird banders give demonstrations in the field at the Hummer/Bird Celebration and often allow festivalgoers, such as this young boy, to assist in the release of a newly banded hummingbird. When a banded bird is later recovered, important information can be gathered concerning migration routes, timing, and patterns.

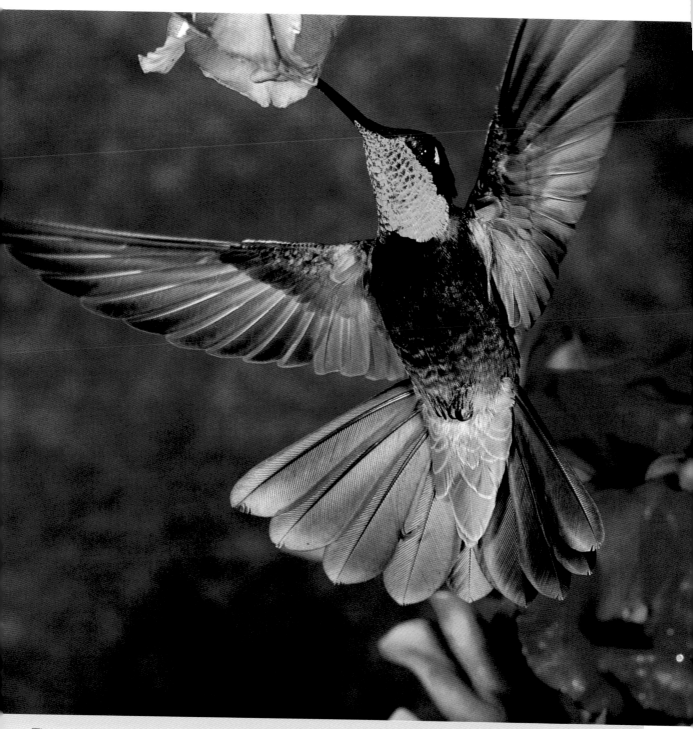

The male Magnificent is a large, dark, almost velvety looking hummingbird. This species feels right at home in mountain forests above five thousand feet in elevation. Of all the western hummingbird species, this one has wandered eastward the least. In Texas, for example, there are only two documented records east of the Pecos River of West Texas.

Hummingbird Discoveries and Destinations

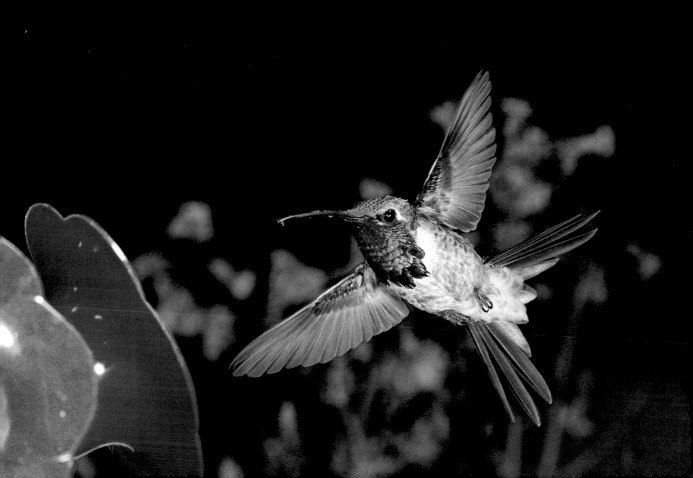

At no other time in history have more people actively pursued wildlife and nature for pleasure and recreation. Nature tourism, ecotourism, and, if you are traveling to find birds, avitourism are among the top activities of the rapidly expanding travel and tourism industry according to the Travel Industry Association of America. State tourism agencies are watching these trends and marketing accordingly. In their efforts to predict which outdoor products to manufacture, the Sporting Goods Manufacturers Association and several federal agencies conduct a survey every six to eight years to look at national recreational trends. In 1996, the National Survey on Recreation and the Environment (NSRE) showed birdwatching as the fastest-growing recreational pursuit in America.

Some of the nation's best-known birding destinations are also well known for hummingbirds. Southeastern Arizona is a popular destination for those birdwatchers who really enjoy seeing a variety of hummingbird species. Texas is also becoming a destination for hummingbird watchers and has now documented more species than any other state (including Arizona), as new discoveries in the Trans-Pecos have revealed a growing number of hummingbird species.

Treasures of the Trans-Pecos and the Hummingbird Frontier

The bird life of Texas is renowned worldwide and has been the subject of study by early naturalists, such as John James Audubon, who came to Texas in 1837, and twentieth-century ornithologists, such as Louis Agassiz Fuertes and George Miksch Sutton. The diverse topography and ecology of the state create a great variety of habitats—forests, coastal plains and wetlands, mountains, deserts, and prairies—bringing ornithologists and birders from around the globe to enjoy these rich natural landscapes.

The Texas Gulf Coast, the Rio Grande Valley, and Big Bend National Park are three of the state's top birding destinations. Recently, another area in the Trans-Pecos region, Fort Davis in the Davis Mountains, has emerged as the state's newest hummingbird hot spot. Jeff Davis County, population just over twenty-two hundred, is located less than 100 miles north of Big Bend National Park and within the migratory path of many western bird species that are normally found in or west of the Rocky Mountains.

Of all the U.S. hummingbirds, the Lucifer has the most pronounced forked tail. Its name is not a patronymic but rather translates to "bearer of light." Besides occurring regularly at a few locales in the southern fringes of the area covered by this book, this species can be found only in Mexico.

New county breeding records, species documentation, and range documentation are all part of exciting, ongoing data-collection projects currently underway by local and state ornithologists. Most of the area's large private ranches have not been systematically surveyed for bird life, and such is the case in the Davis Mountains. But to date, sixteen species of hummingbirds have been recorded in the Davis Mountains, five or maybe six of which breed there.

The landscape in this area is part of an extensive mountain basin and rangeland system; almost all of it is privately held in large ranching units, which up until now have not been readily accessible for exploration. The Nature Conservancy of Texas has helped secure several contiguous large tracts in the hopes of furthering the ecological preservation of this region.

The Treasures of the Trans-Pecos program is designed to recruit more volunteers who have a hummingbird garden or feed hummingbirds west of the Pecos River in Texas. As more bird life is witnessed in the region, more species will be added to the records of these western counties. Especially noteworthy over the past years are new hummingbird records, including the Berylline Hummingbird, recorded first in August 1997 in Jeff Davis County at a private residence in the Davis Mountains Resort.

The impressive hummingbird diversity found in the Trans-Pecos, particularly in Jeff Davis County, has been little known until recently. In August 1995, a well-known bird tour company reported more than ten hummingbird species at one feeder in a two-hour visit. Hummingbirds documented include the White-eared Hummingbird (rare) at higher elevations, Magnificent Hummingbird, and Broad-tailed Hummingbird. The Lucifer Hummingbird, formerly known to occur in Texas only from Brewster and Presidio counties, is occasionally seen at Fort Davis feeders. Black-chinned Hummingbirds are the most common breeders at lower elevations. Rufous Hummingbirds become regular visitors starting each July, along with Anna's Hummingbirds and Calliope Hummingbirds.

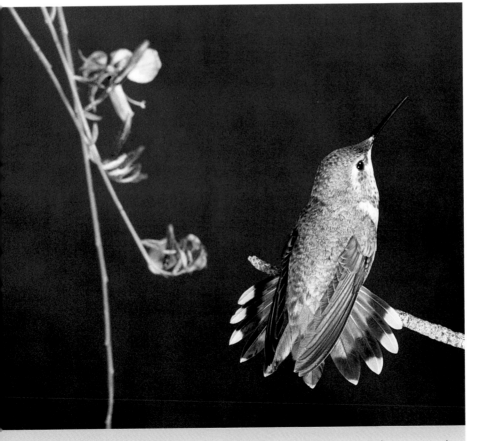

Hummingbirds are very active little birds and almost constantly move and stretch while perched. This female Broad-tailed Hummingbird is stretching its tail feathers, or rectrices (singular, rectrix).

For information on participating in the Treasures of the Trans-Pecos survey, contact the Texas Hummingbird Roundup at the Texas Parks and Wildlife Department at (512) 389-4644 or email nature@ tpwd.state.tx.us. For information on the Davis Mountains Hummingbird Festival, contact the Chihuahuan Desert Research Institute at (432) 364-2499 or www.cdri.org

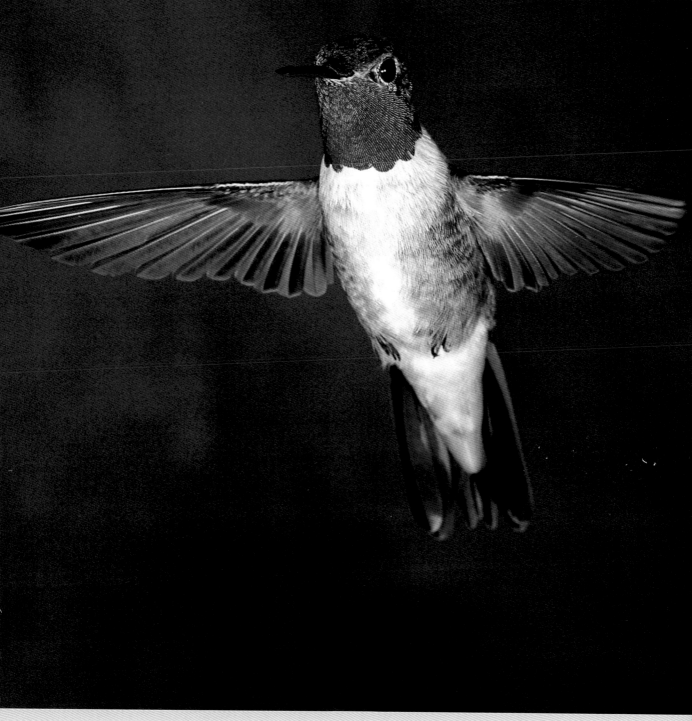

This full frontal view is of a male Broad-tailed Hummingbird. Males of this species produce a loud and distinctive humming noise because of tapered outer wing feathers. West of the Great Plains, the pinkish-red gorget of this species often leads to its being mistakenly identified as the more easterly occurring Ruby-throated Hummingbird. The bright color of the gorget, however, extends all the way to the bill in this species while the Ruby-throated has a black chin and border between gorget and bill.

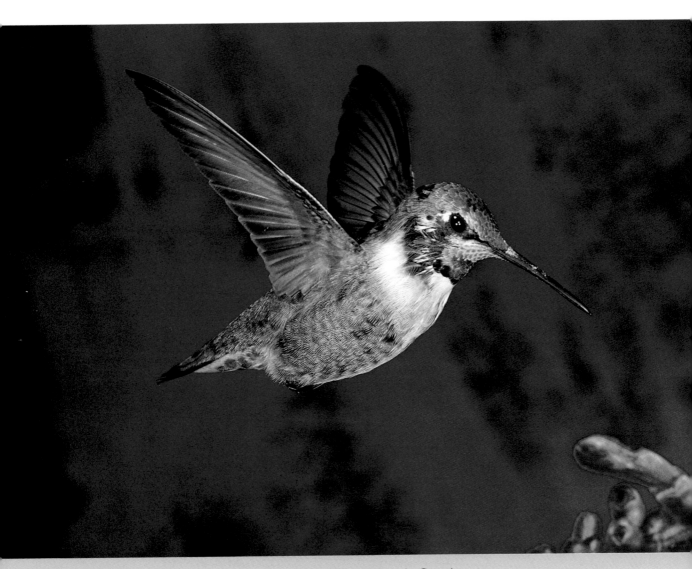

Flecks of dark purple are beginning to appear on this first-year male Costa's Hummingbird. The gray in the face is actually from a lack of feathers surrounding it. The base of feathers is dull gray and is seen well when the normally overlying feathers have molted. Fresh feathers quickly replace the molted ones, and the still rolled-up pin feathers are visible on this molting individual.

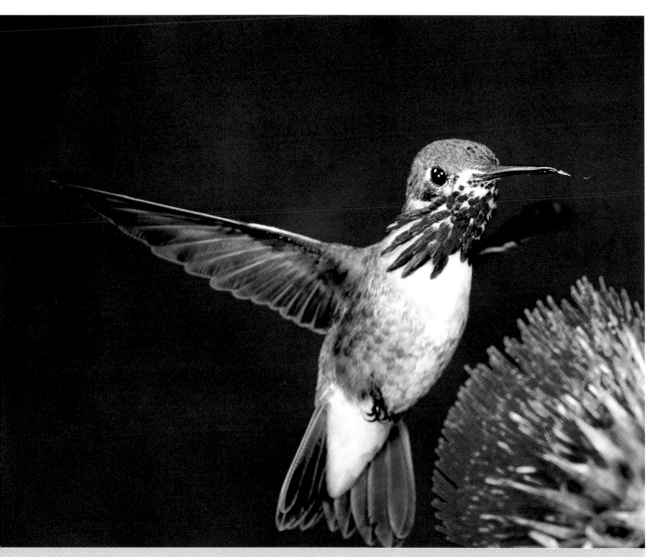

This male Calliope Hummingbird appears to be backpedaling after foraging at a thistle. Hummingbirds are polygamous and thus do not form mated pairs. Instead, males attempt to mate with as many females as possible and leave all the nest building and brood rearing to the females.

Hummingbird Spectacles

It has been another enjoyable year of hummingbird watching. The fall was especially busy with more Ruby-throated hummingbirds than I have ever had. They were in such a constant abundance that my neighbors brought their chairs to be entertained. It was like watching a swarm of bees.

Fort Bend County, Texas, 1995

When wildlife congregates into spectacular visible flocks or herds, wildlife watchers are usually not far behind. Texas is well known for its large concentrations of birds, butterflies, Mexican free-tailed bats, and more, and a lot of travelers come to see them. Spring and fall bird migrations are phenomenal, with great birding spectacles occurring throughout the state. Most notable are the migrations of warblers and shorebirds and the great congregations of waterfowl and raptors. But a wildlife spectacle in miniature has captured the fascination of many people who ordinarily would not consider themselves birdwatchers. The Ruby-throated Hummingbird delivers an economic punch to a community on the central Texas coast in an otherwise ordinarily slow tourist season and also brings pleasure and delight to thousands of people who show up to watch.

One of Texas' most amazing avian spectacles is the annual staging of Ruby-throated Hummingbirds on the Coastal Bend of Texas near Rockport and Fulton. It is so impressive and unique that an annual festival was developed around the phenomenon in 1988, when the community noticed the annual occurrence of great numbers of birds and decided that *their* Ruby-throated Hummingbirds were worth showing off. Although not as readily visible as larger birds in migration, the Ruby-throated migration is just as spectacular in many ways, especially in the birds' great numbers.

It all begins around the first week of September, when hummingbirds start showing up along the Texas Gulf Coast from points north and east. This historic staging area becomes

The Hummer/Bird Celebration held in September in Rockport in the Coastal Bend of Texas is the longest-running U.S. hummingbird festival. In addition to indoor activities such as information booths and presentations, there are field trips to observe hummingbirds in the vicinity. Several other U.S. hummingbird festivals have since been developed and are great ways to learn more about these birds and to exchange information with other hummingbird enthusiasts.

the stopping place for the nation's largest concentration of Ruby-throated Hummingbirds as they prepare for their southern migratory passage. The birds congregate here and fatten up on nectar and protein before departing for the tropics, flying over or around the Gulf of Mexico to points south, mainly central and southern Mexico. For several weeks, birds by the thousands congregate in oak woodlands and backyards in a migratory hiatus and feeding frenzy. Wild Turk's cap, salvia, and other nectar-producing plants supply natural food for many, but others feed on nectar provided in town in colorful backyard feeders.

Enjoying these annual passages, a group of ardent town residents saw an opportunity and took it to heart. They already had birds in their backyards by the hundreds, and to attract even more, in late August they hung additional feeders, with some yards boasting up to twenty-five. Then these citizens planned the Hummer/Bird Celebration, a community-sponsored festival to take place in mid-September in celebration of the birds' arrival. They invited people from around the area—and it worked! Tourists showed up by the thousands.

The festival features a trade show with so much bird paraphernalia that an avid shopper could stay busy all day on a buying spree. Bird experts conduct popular educational programs, covering topics such as bird biology and bird gardening. These programs coincide with birding tours for a complete birding experience. But the main show is the backyard tours where festivalgoers enjoy the spectacle of hundreds of birds in one spot, buzzing and feeding commune-style at backyard feeders. Reports

sometimes include Buff-bellied or Rufous Hummingbirds in addition to the Ruby-throated, but the Ruby-throated is the real star because there are so many of them.

No one knows how long the birds have been staging here along the coast, but the phenomenon has only recently been recorded. Ornithologists speculate that the birds congregate in this area because of its proximity to the Gulf and because of the live oak trees that grow on the coast in clumps, called mottes. These wind-twisted trees accommodate the birds' needs for cover, and the

natural populations of Turk's cap and other nectaring flowers provide the necessary natural food. As they are everywhere, conservationists here are concerned that human growth and development could destroy these historic roosting and staging grounds. The migration spectacle and Hummer/Bird Celebration are well worth a special trip to Rockport, especially if you are a hummingbird lover.

You may learn more about the festival by calling the Rockport-Fulton Chamber of Commerce toll-free at (800) 826-6441.

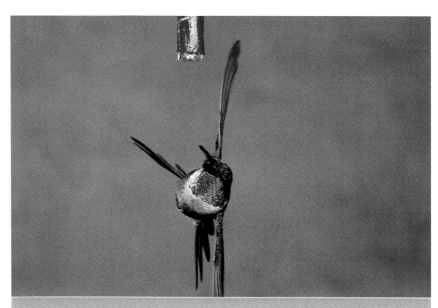

Aerial antics of hummingbirds make them a favorite among nature enthusiasts. The sideways maneuvers of this male Ruby-throated Hummingbird give just a hint of its amazing ability at flight. This angle shows that the male of this species always has a black chin, so the red gorget does not meet the bill. Also obvious is the rainbow effect of the gorget such that it can appear a shade of amber as well as ruby red.

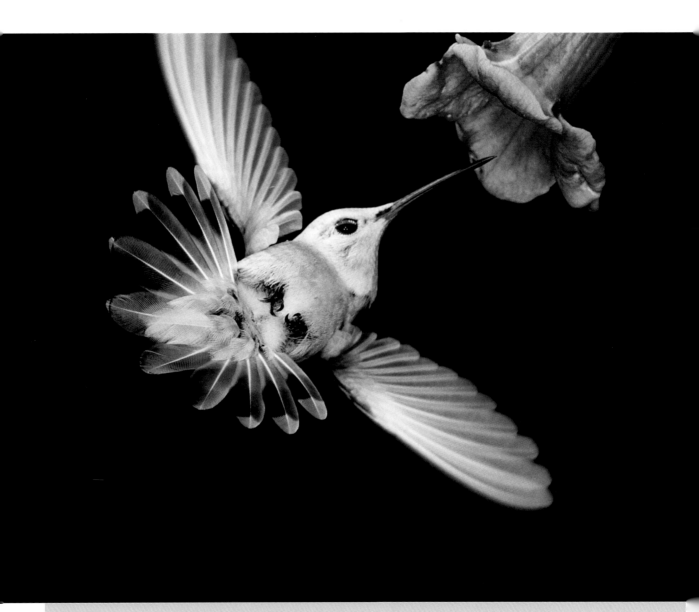

Many observers at the Hummer House in Christoval, Texas, remarked that this partially albino Black-chinned Hummingbird resembled a little angel. Albinism is the lack of melanin, which is the pigment that not only gives color but provides feathers with extra protection against normal wear and tear.

Ranch Birding in Texas

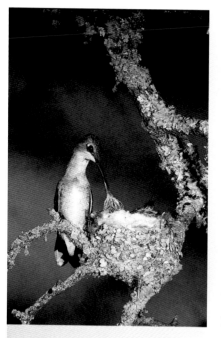

With her long, pointy bill, this female Black-chinned Hummingbird delicately feeds one of her nestlings. She regurgitates a mixture of partially digested insects, which provides the growing young with their much-needed source of protein. When this nesting session is completed, hummingbird nests are often reused that same year, sometimes by a different female. It is not unusual for the same female to raise more than one clutch per year.

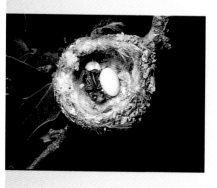

Nests of hummingbirds, such as this Black-chinned, are exceptionally tiny and typically constructed of stretchy natural fibers that allow the nest to increase in size as the nestlings grow inside it. Lichen is gathered by female hummingbirds and placed on the outside of the nest for camouflage purposes. Male hummingbirds take no part in nest construction.

Several large Texas ranches are pioneering by opening their gates to paying birdwatchers. The King Ranch, Kenedy Ranch, El Canelo Ranch, and Fennessey Ranch, all located on the Gulf Coast or in South Texas, are now open for birding tours, which has helped the owners add new revenue to their ranch income. In the past, bird-tour operators would spend hours along a few spots on South Texas highways, hoping to call or hear birds, which were hard to find. With ranch tours on the menu, operators can give their clients a great South Texas birding experience.

Dan Brown's Hummer House

When Dan Brown called the Hummingbird Roundup in 1994 and told the staff that he had used over 350 pounds of sugar for feeding hummingbirds during the previous five-or-so month hummingbird season, the staff scratched their heads in disbelief. That is more than two pounds of sugar per day during the hummingbird season, the greatest amount they had heard of anyone feeding. He also told staff that the birds drained sixteen feeders daily and that he had hundreds of hummingbirds all summer. The amazed staff called back to make an appointment; they wanted to see firsthand. What they witnessed was not only a marvel of nature but perhaps the most wonderful habitat anywhere for breeding Black-chinned Hummingbirds.

From Austin they drove northwest about three hours to the small town of Christoval, Texas, south of San Angelo. There they found a wonderfully peaceful and beautiful environment and a man who obviously derived great pleasure from wildlife and birds. His family heritage included this beautiful West Texas ranch set along the banks of the South Concho River, a place that hummingbirds, if they could talk, might call Nirvana.

The setting was serene as the clear South Concho River meandered through thick groves of native pecan trees with shallow rivulets of water flowing effortlessly on top of the white limestone bottom. The sun was filtered through the deep shade, laying down golden light on the water and revealing a wealth of busy insects darting among wildflowers, low shrubs, and rocks. Small fish and water bugs scurried along. The tree canopy, about thirty feet above the water, provided just the right light for shade-loving species, such as American beautyberry, and other plants. Painted Buntings and Northern Cardinals were singing in the trees, while resident white-tailed deer and wild turkey looked like sentinels guarding the ranch. This place was special just for its natural beauty alone, but it was also special because of its thousands of tiny bird inhabitants. This was the summer home to perhaps the largest concentration of breeding Black-chinned Hummingbirds in Texas or, perhaps, the world.

As they visited, biologists learned that Brown had been providing supplementary feed for these hummingbirds for the past thirty years. His first feeders were handmade in the late 1960s. From years of watching, he had learned a great deal about the birds' behavior. As the

birds frolicked in the water sprinkler under the trees, the afternoon slipped pleasantly away for these visiting biologists, enthralled with a true Texas hummingbird spectacle.

Before the afternoon had ended, they learned that Brown annually found dozens of nests in the massive pecan trees. He had witnessed birds collecting nest material by pulling stuffing from an old, tattered patio chair cushion. Brown saved it and made sure each summer it was available to the birds. He knew when his first birds would likely arrive (around March 15) and knew almost to the day in August when most would leave

and venture south to their wintering homes in central Mexico. Everyone watched as the birds hawked insects in midair between trips to the feeders.

Other hummingbirds documented on-site include Ruby-throated, Rufous, and on occasion, a Calliope. The Browns have added several improvements to accommodate nature enthusiasts wanting to visit this special place. In 1997, they built the Hummer House cottage and later a wildlife observation room.

For more information, call or write to Dan Brown at (325) 255-2254, P.O. Box 555, Christoval, TX 76935.

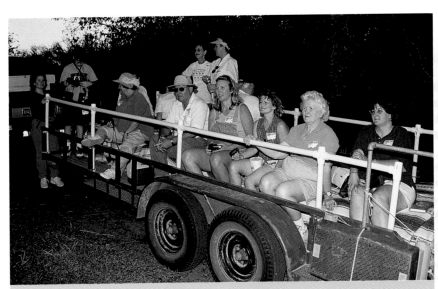

To provide more opportunities to see Ruby-throated Hummingbirds that are congregating in large numbers each September on the Texas Gulf Coast, the Fennessey Ranch offers hayrides for birders and hummingbird enthusiasts on its property in conjunction with the annual Hummer/Bird Celebration in Rockport. By actively supporting nature tourism efforts, you also send a message that you support habitat conservation, which is essential to our hummingbirds and other wildlife.

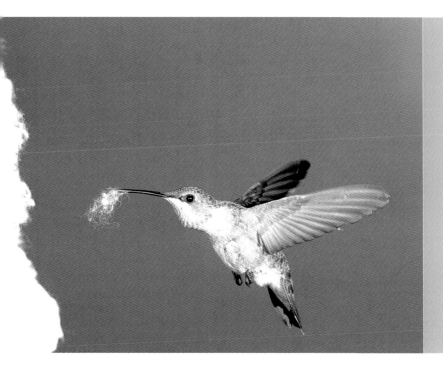

This female Black-chinned Hummingbird is tearing off small strips of raw cotton for lining her nest. Hanging bundles of this cotton outside is a great way to attract nesting hummingbirds as well as other species of birds. Cotton and other natural fibers are woven together to make a cushioned, strong nest that will support fragile eggs and nestlings.

Fennessey Ranch

If watching hundreds of Ruby-throated Hummingbirds in the wild is your passion, then the Fennessey Ranch's hummingbird tours are for you. Located between the Texas towns of Refugio and Sinton, Fennessey Ranch runs for nine miles along the banks of the diminutive Mission River, which empties quietly, almost unnoticed, into the Gulf of Mexico. The ranch holds four thousand acres of coastal woods, prairies, and wetlands that are extremely important habitat for hundreds of migratory and resident bird species. The ranch is located in the heart of the Central Flyway and provides just the right environment of food and cover needed for the fall staging of thousands of birds congregating into groups.

For several weeks beginning in early September, in wind-sculpted live oak mottes surrounded by native stands of Turk's cap, one can observe a true Texas hummingbird spectacle, one of the nation's largest congregations of Ruby-throated Hummingbirds that we know of on private land. They begin arriving from points across the United States, triggered by the shortening of daylight and the first cooling weather.

The Fennessey Ranch is a popular tour feature for the Rockport-Fulton Hummer/Bird Celebration, offering hummingbird hayride tours during which participants witness hundreds of hummingbirds feeding and resting on their migratory journey. On the hayride tour at the ranch, participants are treated to the sight of abundant native Turk's cap and scarlet sage and can view hundreds of tiny hummingbirds in their natural environment. The ranch also reports Buff-bellied and Rufous Hummingbirds, along with a rare Broad-tailed or Black-chinned Hummingbird.

The ranch owner, Brien Dunne, and nature tourism guides opened the gates for this amazing event in 1996. The owner's deliberate decision to maintain the habitat for these birds is a gift to the public, because so much coastal habitat has been developed and/or used for agriculture. Nature tourists who want an opportunity to bird some of Texas' most impressive ranches will enjoy the Fennessey, which is a significant site on the Great Texas Coastal Birding Trail. During the Hummer/Bird Celebration, one can find the ranch operators at their trade-show booth and sign up for the tour. To make reservations, call the ranch at (361) 529-6600.

A Hummingbird Garden

Gardening for birds has become so popular that great numbers of books, magazines, catalogs, retail stores, trade shows, and web sites featuring products and how-to yard and garden enhancements are welling up across the United States. Reinforcing this interest and growth are the backyard habitat programs sponsored by most state and federal conservation agencies, where the public can learn how to attract birds to their homes.

Bird gardening includes anything from bird-watering ponds, misters and drips, and feeders to restoration and enhancement of yards with native plants to attract birds. Once undertaken, these projects become labors of love for the owners, and if they are in just the right area, some yard habitats have become destinations for the traveling birdwatcher. Good examples are the hummingbird gardens along the Great Texas Coastal Birding Trail and the wonderful backyards sometimes open for viewing by birding hosts in several states.

Picture yourself relaxing on your home patio, a glass of iced tea beside the chair and a good book in hand, watching as the butterflies flit from flower to flower in your backyard garden. Suddenly, your eye is caught by a radiant glow of jewel-like light from the throat of a passing male Ruby-throated Hummingbird as he darts to a nearby flower. Few outdoor activities provide a greater sense of accomplishment than developing a landscape for wildlife—watching as birds, butterflies, mammals, and other wildlife make our home their home. With hummingbirds, this accomplishment is often rewarded quickly and with a variety of beautiful pollinators buzzing about our yards.

A first encounter with a hummingbird often results in a trip to the local feeder store to shop for the perfect feeder for the yard. Although everyone thinks of a hummingbird feeder to attract hummingbirds, the feeder should only supplement a well-planned and carefully developed

Wildscapes are beautiful and easy to maintain. They not only provide nectar for hummingbirds but also attract gnats and other tiny flying insects that hummingbirds must eat to obtain protein and vitamins. Human-made feeders supply only sugars as fuel, but hummingbirds require protein to survive. Instead of using insecticides, allow hummingbirds and other insectivorous birds to be natural pest-control agents near your home.

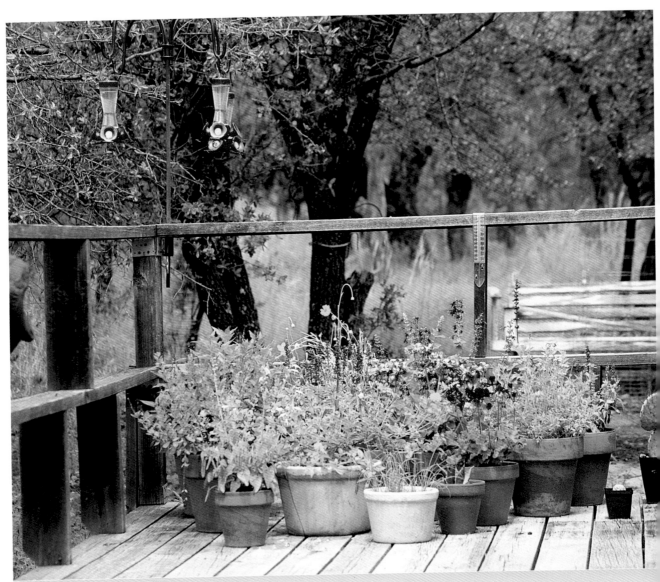

Feeders are important when attracting hummingbirds, but so are colorful, nectar-giving flowers. Consider wildscaping, using only native species. Potted plants can provide an attractive nectar source in patio gardens, town homes, or apartment complexes.

landscape to be most effective. Placement of these feeders in a garden landscaped with hummingbirds in mind will optimize your opportunities to see and enjoy their visits. Hummingbird gardening is simple and fun because it combines two enjoyable pastimes into a single activity: gardening and birding.

Gardens maintained to attract hummingbirds should attempt to create the natural conditions the birds prefer. Because our southwestern hummingbirds occur in a wide variety of natural habitats, including canyons, meadows, riparian areas, forest edges, and woodland openings, the options we have are varied. Developing an effective hummingbird garden, like planning habitat for any other species, requires us to provide food, water, and shelter in an area that makes it effective and available for the birds. These items can be provided through either natural or human-made products, but often the best way to provide the habitat is through a combination of naturally occurring and supplemental resources.

Turk's cap is a prime example of a native nectar-giving plant that hummingbirds target. In order to attract hummingbirds to your property, consider providing a landscape that will attract wildlife. "Go native" with whatever species you decide to plant. A bright, showy plant species does not necessarily produce nectar. Careful planning and thought should go into any backyard wildscaping effort.

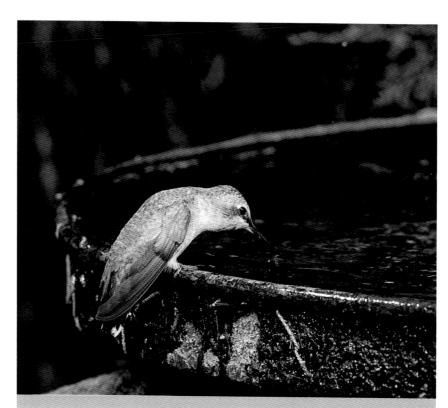

Hummingbirds, like this female Black-chinned, can usually obtain plenty of moisture from nectar, but they still need to drink water, especially in arid regions. Providing all birds with a clean, regularly maintained birdbath is quite rewarding for homeowners and landowners.

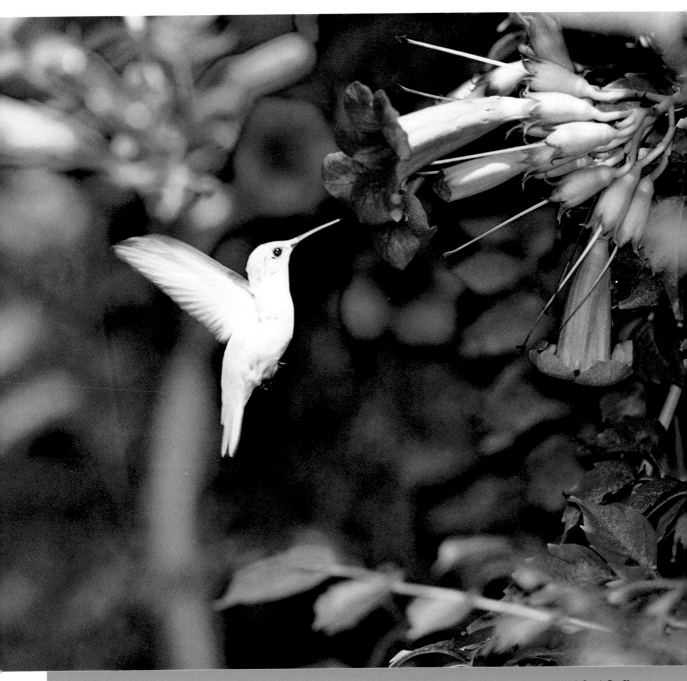

This ghostly white Ruby-throated Hummingbird from Corpus Christi, Texas, was an unusual find. Buffy hints appear on various parts of this bird, thus it is known as a leucistic individual (referring to dilution of color). Complete albinos, which are totally white with pink eyes and pink legs, are very rare in the bird world.

Food, Water, Shelter

Food for hummingbirds consists of a high-energy source and a source of protein. Energy sources are those we often think of, such as nectar from plants and sugar water from feeders. Hummingbirds also secure protein in their daily activities by feeding on insects and spiders in and around the plants they frequent. Providing this well-rounded food source will require floral variety, rich nectar sources, overlapping bloom periods, and a healthy insect-spider community that nature provides.

Providing reliable sources of nectar means providing nectar-producing plants that will bloom throughout the period that hummingbirds are expected in the region. In Texas and the other southwestern states, this means providing nectar sources year-round. Flowers that are attractive and provide nectar to hummingbirds in the spring are readily available, as this is the time many gardeners want the color of plants to brighten their yard. Finding a reliable plant to bloom in early January is often more difficult. The tropical wonders we often look for, because of their bright colors and unusual shapes, are often too tender if frost occurs. This makes plant selection and cultivation critical. Native plants can provide a solution, especially if we are familiar with their habitat and climate needs.

A good nectar-producing plant that will be attractive to hummingbirds is usually going to have a trumpet-shaped flower, with a deep throat and wide mouth. Plants such as those in the salvia family lend themselves to the foraging efforts of hummingbirds, providing a small store of sweet nectar at the base of a deep flower. Color is important in attracting these birds; they have a well-known affinity for red, but once they are in your garden, any source of nectar from any color flower is likely to be explored.

Through the Hummingbird Roundup, the Texas Parks and Wildlife Department has kept track of the plants in Texas that hummingbirds seem most likely to feed on. Salvias were by far the most popular plants. Observers reported salvias as the most preferred plant 33 percent of the time. Other frequently mentioned plants include trumpet creeper, lantana, hibiscus, and Turk's cap. All of these plants are native to the area covered in this book. Other plants frequently mentioned include tree tobacco, lemon mint and other members of the mint family, shrimp plants, and

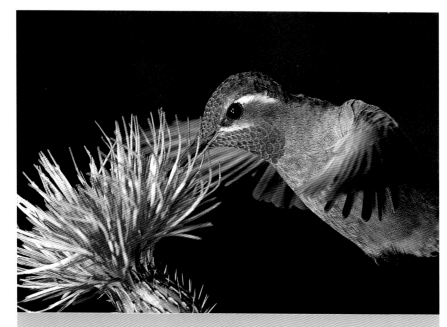

Hummingbirds feed on a variety of nectar-producing plants. This male Blue-throated Hummingbird is working on a thistle. The two white facial stripes and the blue throat are very distinctive in the male of this species. The Blue-throated Hummingbird and the Magnificent Hummingbird are the two largest U.S. hummingbird species.

vining plants such as morning glory. Try to avoid the trap of "flashy color means nectar value" when selecting your plants. Bougainvillea, with its brightly colored flora, has little nectar value for the hummingbirds; it will draw them to your yard but will not sustain them.

Supplementing your hummingbird garden with a source of sugar water will help keep the birds around the garden during the periods of low plant blooms. It could also help increase the hummingbird numbers in your garden. Hummingbird feeders can be purchased at a wide variety of department stores, bird supply stores, garden centers, and even grocery stores. Solutions can be bought to make the sugar water, but a 4:1 mixture of boiled water to sugar, then cooled, is perfect for filling feeders. Red food coloring is unnecessary and may actually be harmful to the birds. Your feeder should be placed in an open area, where the birds can see it easily and can approach it without fear of ambush from predators.

Natural water sources include flowing streams, lakes, seasonal waterways, and ponds. Hummingbirds will use all these if the water is shallow enough, the bank slope gradual enough, and the water flow gentle enough. Most of us are not fortunate enough to have these water supplies close by. Instead, supplemental water is often necessary.

Birdbaths, misters, and drip fountains are the artifacts most commonly used by hummingbirds, with the misters being most popular. The fine mist provided by one of these devices offers the bird water for bathing and drinking in an unthreatening manner. Many Hummingbird

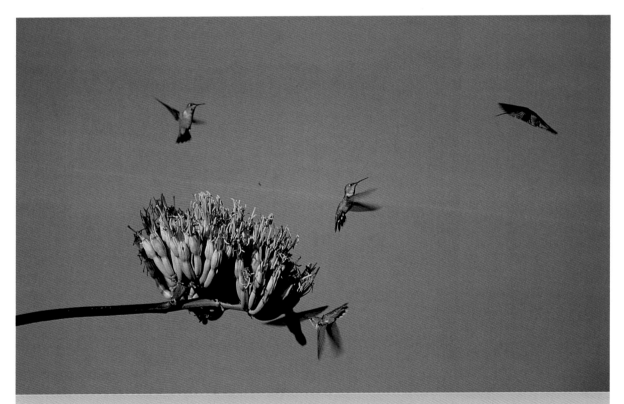

Many flowering plants depend on hummingbirds for pollination. Without hummingbirds and other plant pollinators such as butterflies, bees, and wasps, many species of plants would be unable to propagate. These five Rufous Hummingbirds were all attracted to this flowering agave. The hummingbird is rewarded with sweet nectar from the plant, and the plant is pollinated by the hummingbird.

Roundup participants reported providing water for the birds, and those who did were often rewarded with birds bathing in or drinking the water. Several Roundup participants reported hummingbirds flying back and forth through the water thrown from the misters and sprinklers.

Shelter is an often overlooked concern for hummingbirds. Because these birds use their speed and maneuvering abilities to escape predation, we often ignore their need for a nesting or resting site nearby. Hummingbirds tend to nest in mature trees, often from five to fifteen feet off the ground—the very range that many of us tend to remove to improve the view. A tree with appropriate canopy cover in this height range near a feeder is likely to invite hummingbird nesting activities to your yard. Look for nests in sheltered parts near, but not necessarily on, the outer reaches of the trees.

Trees serve an additional purpose of providing perch sites for hummingbirds. Expect to find perching hummingbirds in areas where they have a ready view of the sky and ground. Ever vigilant to spot potential predators or competitors, the hummingbird likes to see the opposition first.

Consistent numbers of wintering hummingbirds are a phenomenon that many in Texas and the Gulf Coast states have been able to observe in recent years. Several species of hummingbirds will overwinter along the Gulf Coast, with some species wandering even farther inland. Shelter seems to be the primary factor in keeping birds in your area through the winter. Shelter at this time of the year has to focus on protection from the harsh climate and address resting and escape concerns. Evergreen coniferous and broad-leaved plants

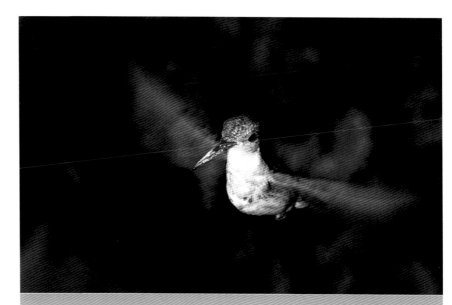

If the sexes of birds are indistinguishable in the field, the birds are considered sexually monomorphic. The broad base to the red bill is not often observed, as it is in this adult Violet-crowned Hummingbird. This species is unusual anywhere in the United States, so birdwatchers were very fortunate to have snapped documenting photographs of it on the upper Texas coast in early March 1998—the first documented report east of the 97th meridian in the entire United States. The species was seen only for a short period during one day, which demonstrates the importance of a ready camera as an essential tool for any birdwatcher. Photos can assist with convincing even the staunchest skeptic.

will provide protection from the cool winds and rains.

So what does a good hummingbird garden look like? To summarize, it needs plenty of open sky for the birds to fly in, while still providing shelter for nests and resting. A large open area surrounded by trees and brush providing shelter in the five-to-fifteen-foot range is ideal. Within the open area, as well as under the trees, should be a variety of plants such as salvia, honeysuckle, trumpet creeper, lantana, and Turk's cap. The plants should not be blooming simultane-

ously but rather consecutively, providing a food source throughout the season. Under the eaves or hanging from garden decorations, where the hummingbirds can see around them, should be hummingbird feeders filled with sugar water. Nearby should be a water source, preferably moving water, with shallow points where the birds can sit and bathe. For help in planning and developing this hummingbird paradise, we recommend *Texas Wildscapes: Gardening for Wildlife* by Noreen Damude and Kelly Conrad Bender (Texas Parks and Wildlife Press, 1999).

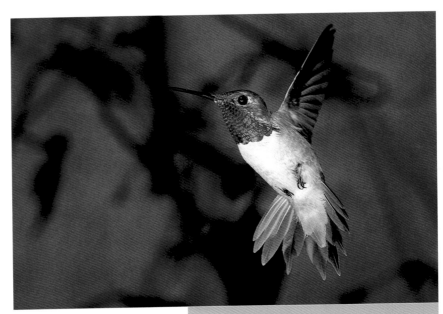

In order to be more streamlined during flight, hummingbirds such as this male Rufous tuck their feet up to reduce drag. If a hummingbird is observed vigorously flying around in one opening or sunny spot, the chances are good that it is hawking a swarm of tiny flying insects. These prey items might be minuscule gnats or mosquitoes, but with binoculars observers can sometimes see the bird grabbing dozens of these protein-rich morsels in midair with the tip of the bill.

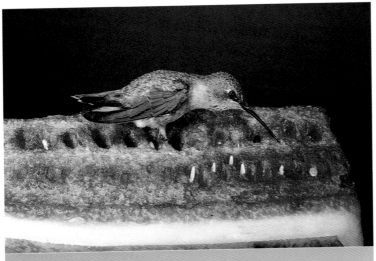

Fruit is an important source of nourishment for many birds. This female Black-chinned Hummingbird is in an unusual pose as it perches directly on a watermelon slice to feed on the sweet juices. In addition to exposed fruit, tree sap is an irregular food source among hummingbirds. Some individuals will drink from active sap wells drilled by sapsuckers from the woodpecker family. Hummingbirds also have been observed feeding in mature oak trees, where tiny droplets of sap ooze from the scar where an acorn has recently fallen from its cup.

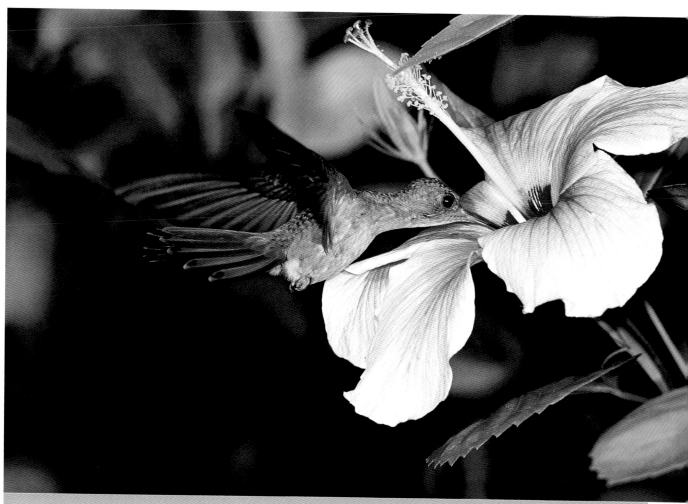

The Cinnamon Hummingbird, typically found south of the U.S.-Mexico border, has been recorded in the United States only a couple of times. One such record occurred in New Mexico just a few miles from El Paso, Texas. This individual was photographed at a hibiscus on the pacific slope of Mexico. It is a large hummingbird in the genus *Amazilia* and resembles two of its close U.S. relatives (Buff-bellied and Berylline), but the entire underside of the Cinnamon Hummingbird is a rich, rusty wash. This species is an example of one of several tropical hummingbirds that could appear just about anywhere as a vagrant in the area covered by this book (see the table on p. 68).

Putting It All Together

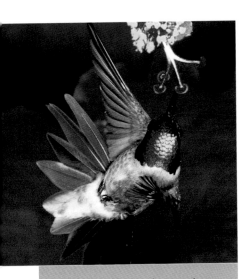

This male Ruby-throated Hummingbird is feeding on a hibiscus. The color red does attract hummingbirds, but it is best not to include dyes in the sugar water of your feeder. Instead, make sure the feeder itself has red parts, or simply tie red ribbons nearby to get the birds' attention.

A typical reaction after getting a list of plants that will attract hummingbirds is to fill a shopping cart with as many of the different plants as can be found at the local nursery. However, a garden, like any other worthwhile effort, is best when approached from a carefully planned perspective.

The first step in planning a hummingbird garden should be to map the existing facilities, especially those you are not likely to move. Put these features on paper, so you know what you have to work with. The initial step should also include the identification of all existing trees and any other landscape features, as well as areas of the property that are used for specific purposes (for example, a patio, playground, swimming pool, or dog pen).

Are there some private areas you want screened from the neighbors? Do you plan to add utility or recreation areas to your property? Where do you want to feed the hummingbirds? Are you planning to provide nesting shelter for the birds? If so, where? Having these areas designated on your map will help you to determine what specific purposes each flower bed will serve at the next step.

In planning for the utility of each flower bed you create, map that bed with specific goals in mind. How tall do you want these plants to get? Are they to produce nectar, add shelter, or provide color? Do you plan to attract species other than hummingbirds into the yard? What predation and safety issues need to be addressed through the plants in this garden? Will you have feeders, water features, or landscape ornaments in the garden? Answer these questions before selecting the specific plants you will need. The more planning and the greater care you take to this point will reduce your frustration at the next level.

Next, look through plant catalogs and visit your local nurseries as you select specific plants you have identified for the garden. Nectar sources might include several native species of salvia. You may want to add a bush such as coral bean or a vine such as trumpet creeper. Shelter trees include mature hardwoods, such as live oak or pecan, depending on where you live. Choose native plants whenever possible. Identifying the plant to meet the need is easier than trying to place a plant when you really do not have a need for it. Some of the more popular and readily available plants for hummingbirds are identified in the list on pages 44–45.

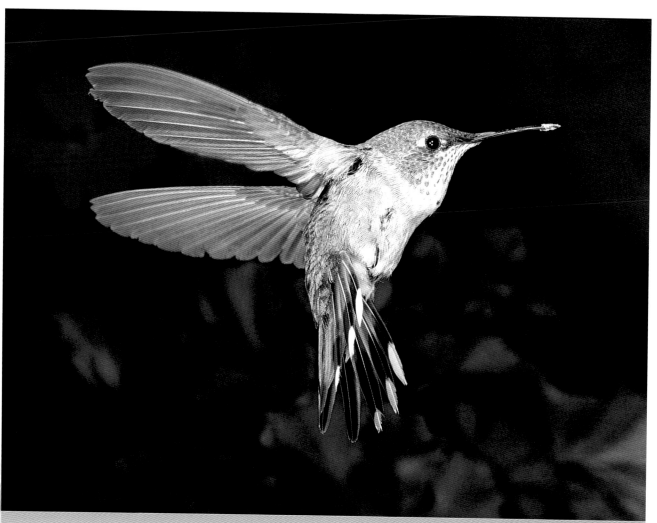

This female Broad-tailed Hummingbird has its bill tip covered with plant pollen. Pollen of various colors, especially yellows and whites, often sticks to the forehead, chin, or face of a hummingbird, which, in turn, can create identification headaches for an observer. Flat yellow is not a natural color found on the head of any U.S. hummingbird. Other confusing colors occur when a licensed bird bander or researcher color-marks a hummingbird with nonpermanent paint. A spot of paint is placed most often on the forehead or crown of the hummingbird being monitored or studied. Different colors allow the observer to watch different individuals.

Hummingbird Feeding Plants

ACANTHUS FAMILY:
> **Flame acanthus**
> > (*Anisacanthus wrightii*)
> **Dwarf anisacanthus**
> > (*Anisacanthus linearis*)
> **Shrimp plant**
> > (*Beloperone guttata;*
> > **non-native**)

AGAVE FAMILY:
> **Century plant**
> > (*Agave americana*)
> **Red yucca**
> > (*Hesperaloe parviflora*)

BLUEBELL FAMILY:
> **Cardinal flower**
> > (*Lobelia cardinalis*)

BORAGE FAMILY:
> **Texas olive**
> > (*Cordia boissieri*)

BUTTERCUP FAMILY:
> **Texas clematis**
> > (*Clematis texensis*)
> **Wild columbine**
> > (*Aquilegia canadensis*)

CACTUS FAMILY:
> **Hedgehog cactus**
> > (*Echinocereus triglochidiatus*)

CATALPA FAMILY:
> **Crossvine**
> > (*Bignonia capreolata*)
> **Desert willow**
> > (*Chilopsis linearis*)
> **Esperanza**
> > (*Tecoma stans*)
> **Trumpet creeper**
> > (*Campsis radicans*)

FIGWORT FAMILY:
> **Cenizo**
> > (*Leucophyllum frutescens*)
> **Cup-leaf penstemon**
> > (*Penstemon murrayanus*)
> **Havards penstemon**
> > (*Penstemon havardii*)
> **Indian paintbrush**
> > (*Castilleja indivisa*)
> **Snapdragon vine**
> > (*Maurandya antirrhiniflora*)
> **Three-flower penstemon**
> > (*Penstemon triflorus*)
> **Wright's penstemon**
> > (*Penstemon wrightii*)

FOUR-O'CLOCK FAMILY:
> **Colorado four-o'clock**
> > (*Mirabilis multiflora*)
> **Hierba de la hormiga**
> > (*Allionia incarnata*)
> **Scarlet four-o'clock**
> > (*Mirabilis coccinea*)
> **Scarlet muskflower**
> > (*Nyctaginia capitata*)

HONEYSUCKLE FAMILY:
> **Coral honeysuckle**
> > (*Lonicera sempervirens*)
> **White limestone honey-suckle**
> > (*Lonicera albiflora*)

HORSECHESTNUT FAMILY:
> **White buckeye**
> > (*Aesculus glabra* var. *arguta*)
> **Red buckeye**
> > (*Aesculus pavia*)

LEGUME FAMILY:

 Anacacho orchid tree
 (*Bauhinia congesta*)
 Eastern coral bean
 (*Erythrina herbacea*)
 False indigo
 (*Amorpha fruticosa*)
 False mesquite
 (*Calliandra conferta*)
 Lead plant amorpha
 (*Amorpha canescens*)
 Rattlebush
 (*Sesbania drummondii*)
 Smooth amorpha
 (*Amorpha laevigata*)

LOGANIA FAMILY:

 Carolina jessamine
 (*Gelsemium sempervirens*)
 Pink-root
 (*Spigelia marilandica*)

MALLOW FAMILY:

 Globe mallow
 (*Sphaeralcea angustifolia*)
 Heart-leaf hibiscus
 (*Hibiscus cardiophyllus*)
 Turk's cap
 (*Malvaviscus arboreus* var.
 drummondii)

MINT FAMILY:

 Autumn sage
 (*Salvia greggii*)
 Cedar sage
 (*Salvia roemeriana*)
 Mountain sage
 (*Salvia regla*)
 Prairie brazoria
 (*Brazoria scutellarioides*)
 Purple horsemint
 (*Monarda citriodora*)

 Texas betony
 (*Stachys coccinea*)
 Spotted beebalm
 (*Monarda punctata*)
 Tropical sage
 (*Salvia coccinia*)
 Wild bergamot
 (*Monarda fistulosa*)

MORNING GLORY FAMILY:

 Cypress vine
 (*Ipomoea quamoclit;* non-
 native)
 Red morning glory
 (*Ipomoea coccinea;* non-
 native)
 Scarlet morning glory
 (*Ipomoea cristulata*)

OCOTILLO FAMILY:

 Ocotillo
 (*Fouquieria splendens*)

PHLOX FAMILY:

 Drummond's phlox
 (*Phlox drummondii*)
 Standing cypress
 (*Ipomopsis rubra*)

ROSE FAMILY:

 Prairie rose
 (*Rosa setigera*)

SOAPBERRY FAMILY:

 Mexican buckeye
 (*Ungnadia speciosa*)

VERBENA FAMILY:

 Calico bush
 (*Lantana urticoides*)

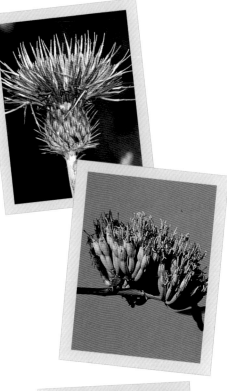

Feeders

Hummingbird feeders should be a supplement to a healthy, flowering hummingbird garden, especially when few or no blossoms are present to offer the birds a natural source of nectar. These sources become more important as large numbers of hummingbirds visit home gardens during migration, and the rate at which the sugar water diminishes in feeders reflects their needs. In their struggle for dominance at the feeders, the birds will expend a great amount of energy while consuming huge volumes of sugar water. Properly maintained, these feeders can attract birds to your garden while presenting you with an excellent opportunity to observe hummingbirds up close.

A trip to a well-stocked bird-feeding specialty store can often be confusing, frustrating, and even intimidating. Hummingbird feeders alone can offer more variety than the average soda aisle in your local grocery store! How can you know which feeder to buy? Is the feeder going to attract hummingbirds, or will it become another decoration in an already crowded wildscape? When hummingbirds are present, almost any kind of nectar-holding feeder will attract their attention, as will any splash of color in the garden. Feeders are usually constructed with at least some red plastic that serves as an attractant. Selection of the feeder should be more for your utility and ease of maintenance than as an attempt to attract the bird.

Maintenance of a bird feeder is one of the least discussed but most important factors in the feeding of any bird. Mention of cleaning and changing the food in a bird-feeding program is often met with surprise. A common reply from backyard birders and gardeners to the question "When did you last change the food in the feeder?" is "The hummingbirds have not eaten what I put out for them—why would I change it?" Feeders should be emptied, cleaned, and refilled with great regularity, especially in the hot Southwest. The artificial nectar may spoil

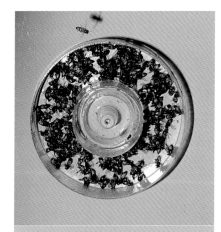

Good design is essential in hummingbird feeders. Some feeders with large ports allow bees to crawl inside, but the bees rarely ever find their way back out. The lid was removed from this feeder to show dozens of dead bees that lay in the bottom of this poorly designed feeder. Shop and investigate before you buy.

quickly in hot weather (and will be like serving curdled milk to the family at breakfast), so a two- to four-day cleaning cycle is recommended during the hot weather, whereas a four- to six-day cycle may work well during cooler periods.

Some feeders are easier to clean than others; this should be a prime consideration when selecting a feeder. A unit that comes apart easily works best. Feeders with fancy designs and shapes with a lot of sharp corners and small compartments should be avoided, because these areas are difficult to clean and become a refuge for fungus and bacteria. Convenience and safety for the birds should always take precedence over appearance where feeders are concerned. Remember the rule that form should always follow function (and never the reverse).

When changing the sugar water, it is a good idea to take the feeder apart and wash the inside and ports well. Simply use soap and water (no bleach or other harsh chemicals) and a good bottle brush, using a smaller brush for the feeding portholes. The feeder should be rinsed and dried before remounting with a fresh batch of sugar water.

Once the feeders are clean, a mixture of four parts boiled water and one part white table sugar should be used to fill them. Honey, which is the wrong type of sweetener, should never be substituted for sugar. Red food coloring, another common and unnecessary additive to the mix, should be avoided. The red on the feeder is more than enough to attract birds. Although there are no data to support it, there might be negative effects from these tiny birds' ingesting food coloring. In short, because it is not necessary to add the food coloring, why do it?

Hanging the feeders is a very critical decision to the success of the hummingbird garden and the sanity of the hummingbird gardener. The most common place to hang the feeders is from a shaded tree to keep the feeder out of the sun. This, however, increases the potential for harm to the birds (from a predator) and increases the probability of ant problems at the feeder. Hanging the feeder from a place that provides shelter but allows the birds a view of open space around them seems to increase the safety of any humming-birds attracted to the feeder. Some

of the most heavily used feeders are in open yards, but this decreases the shelf life of the food, making it necessary to change the food more frequently. Under the eaves of your home and under the edge of a porch or gazebo far from windows where collisions can occur seem to be the most suitable locations for feeders. The distance between feeders does not seem to reduce the fighting among birds unless the feeders are placed on either side of the house where one cannot be seen from the next.

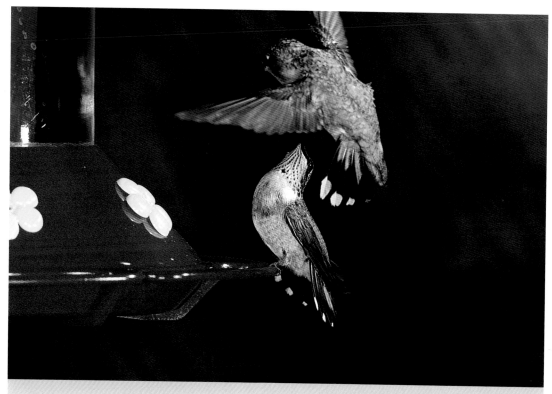

Hummingbirds diligently defend nectar resources in their territory. These two female Ruby-throated Hummingbirds are fighting over a feeder port. Feeders should be maintained with regular cleaning and scrubbing and by replacing the sugar water every few days, especially in the heat of summer.

Visitors, Pests, and Predators

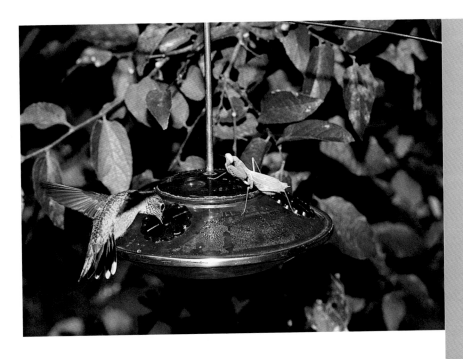

Hummingbirds have several predators, one of which is the praying mantis. This carnivorous insect is patiently stalking a female Broad-tailed Hummingbird at a feeder. Large individuals of these predatory insects can easily capture, kill, and consume an adult hummingbird.

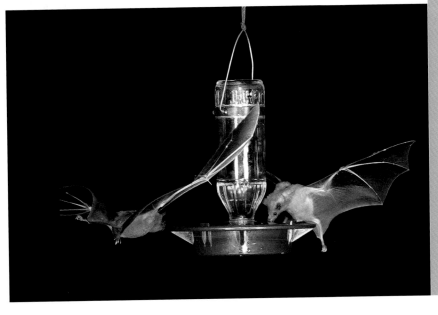

There are very few species of bats that feed on nectar in the United States, such as these lesser long-nosed bats (*Leptonycteris curasoae*). This species specializes on agave but is also attracted to hummingbird feeders during the nighttime. Like hummingbirds, butterflies, and moths, these bats are essential pollinators for several species of plants, which is important for biological diversity, aesthetics, and agriculture.

Although none of us like to think about it, basic realities of life include hummingbirds serving as prey for other animals, known as predators. Care in developing and maintaining your garden will ensure that predation around your feeder is minimal, but there are no guarantees that it will not happen.

Free-roaming house cats are a significant threat to hummingbirds, as they are to all wildlife. Because house cats are not native to North America and have been introduced, sheltered, and cared for by humans, they are unique predators. They are usually protected from disease and fed by their owners, so they do not face the hardships that often keep predator numbers in check. It is difficult to estimate the number of house cats in the United States. The 1990 census estimated 60 million, but this number reflects only those cats that people claim to own as pets. Feral cats may push that number to more than 100 million, most of which are concentrated in areas near people, which compounds the effects of predation with those of habitat loss.

Although people may like to think that their cats do not hunt, recent studies suggest that 90 percent of free-roaming cats feed on wildlife and that less than 10 percent of these cats kill no animals at all. Their hunted prey does include rodents, but it also includes birds. Hummingbirds are not exempt from the menu.

Nationwide, rural cats are estimated to kill hundreds of millions of wild birds each year, including hummingbirds. Bells and other warning devices seldom significantly reduce cat predation. Often, by the time the cat predation. Often, by the time the bird hears the bell, it is too late for an effective escape. Preventing the attack is more a matter of reducing opportunity than warning the prey. There are some things, as suggested in the following list, that both cat owners and responsible wildlife enthusiasts can do to reduce the impact cats are having on our wildlife. For more information on the impact of cats on wildlife, please search the World Wide Web, especially the American Bird Conservancy's Cats Indoors! Campaign.

1. Make your cat an indoor cat. They are safer themselves and live longer. Encourage your friends, family, and neighbors to do the same.

2. Place your feeders in open areas where cats cannot approach the birds unseen. Remember that you are inviting the birds onto your property; keep them as safe as possible.

3. Keep your feeders at least five feet off the ground and ten feet from neighboring trees or other cat-lunging points.

4. Control access by stray animals to outdoor cat food, as well as any dishes intended for other outdoor pets, and keep all garbage cans sealed.

5. Do not feed stray cats.

6. Some people have reported planting thorny vines such as blackberry or dewberry beneath and around the feeders to help repel cats.

Although hummingbirds are small and generally not worthy of consideration by birds of prey, members of other groups, such as shrikes, will occasionally take a hummingbird if one is available. Preventing such attacks again involves allowing the hummingbird to see what is approaching, especially from above. Placing hummingbird feeders under overhanging branches allows other birds to approach unnoticed until it is too late for the hummingbird to avoid the attack. A fleeing hummingbird will seldom escape toward a tree; its short, powerful wings, which allow maneuverability and speed, make it possible for it to outrun most avian attacks. With this in mind, placing feeders in the open allows the hummingbird direct access to its preferred escape.

Many hummingbird enthusiasts might be surprised by what kinds of other predators there are. Praying mantises have been observed waiting patiently on a feeder for the unsuspecting hummingbird to perch. Greater Roadrunners and even large garden spiders and their webs have been known to take a hummingbird. Vigilance and careful placement of the feeder are, again, the best methods for reducing such attacks.

The greatest threat to hummingbirds continues to be humans, who love to see the birds through glass windows. Feeders hung too close to a window will bring the birds close but may also create a hazard. Birds of all sorts simply see blue sky, clouds, vegetation, and so on in the reflective glass and fly at full speed directly into the window. Breaking up the window's reflectivity with a curtain, screen, or hanging (potted) plant will reduce these impacts.

"What can I do about the wasps that seem to gather around my feeder?" This question or a similar one on ants is one of the most common questions asked regarding pests at feeders. Pesticides, the common tool to reduce wasps around the house, should never be used at or near the feeder because these chemicals are harmful to the birds.

The cause of pest problems is the tempting food we put in the feeders because ants, wasps, and bees also seek the nectar of flowers (or in this case, sugar water). Controlling the access to sugar water, reducing the temptation, and even providing an alternative food source for these nontarget species are all answers suggested by Roundup participants.

Bees and wasps can detect scents carried by the wind. Reducing the amount of spillage around your feeders often will result in fewer flying insects. A second concern comes from the design of the feeders. Generally, feeders that position the port above the reservoir as opposed to the side will have fewer spillage problems and thus fewer flying-insect problems. Feeders with bee guards increase the distance between the port and the

Flying creatures are not the only nectar lovers out there. This green anole lizard (*Anolis carolinensis*) was caught in the act of gulping at this hummingbird feeder.

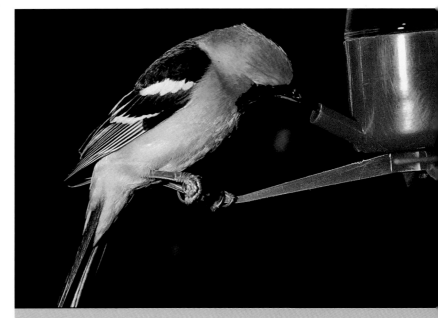

Orioles, such as this Hooded, are especially fond of nectar and are sometimes considered unwanted pests at the feeder. They are heavy birds and, while perched on a feeder, can tilt it in such a way that causes it to drain completely. Oriole-specific feeders of a different design are available on the market for those who wish to support orioles while their traditional hummingbird feeders support the hummingbirds.

ood and make the nectar inacces-ible to most bees.

Another method for controlling bees and wasps is to provide an alternative source of food. Mixing a different and slightly stronger solution, placing it in an open dish, and immersing a cloth in the solution will make an excellent feeder for wasps and bees and might deter them from any hummingbird feeder. The bee feeder should be placed well away from the house in an area where you do not mind these visitors. Planting certain species of plants favored by these insects, including Mexican heather, will attract them as well and will hopefully leave the hummingbird feeders for the hummingbirds.

Ant problems generally develop when the feeders are placed on trees where ants regularly feed. Like the flying insects, once ants locate a food source, they are difficult to discourage. Avoid tree-mounted feeders. Hang them from your eaves far away from windows or from a freestanding yard ornament if possible. Ants can also be discouraged by the addition of ant traps, either homemade or commercial ant moats, secured between the mounting structure and the feeder. These provide a barrier between the ants and the food.

Not all visitors to your feeders will fit easily within the category of pest or predator. Certainly no one would consider an oriole a pest, and a variety of orioles visit hummingbird feeders in Texas, New Mexico, and Arizona. Other visitors might include House Finches, Orange-crowned Warblers, Verdins, and even a variety of woodpeckers. The biggest concern would probably be spillage caused by these heavy birds, which do not hover and must cling to the feeder, thus tipping it to one side.

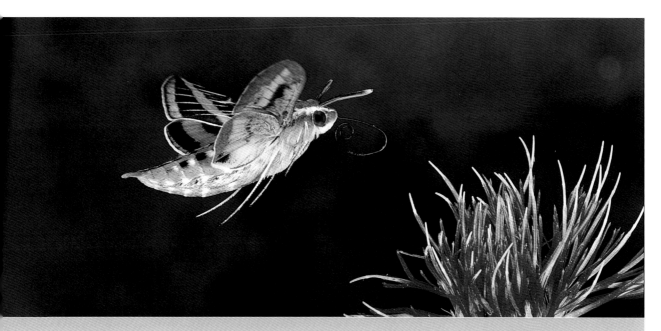

There are several species of sphinx moths commonly known as "hummingbird moths," which forage by day or night. Like hummingbirds, they hover at flowers or feeders but insert a long proboscis for nectar. When a report of a hummingbird known as a coquette from Latin America is made in the United States, it is undoubtedly a misidentification of the sphinx moth. Coquettes are tropical-inhabiting hummingbirds to our south and are not expected to visit the United States.

Overwintering Hummingbirds

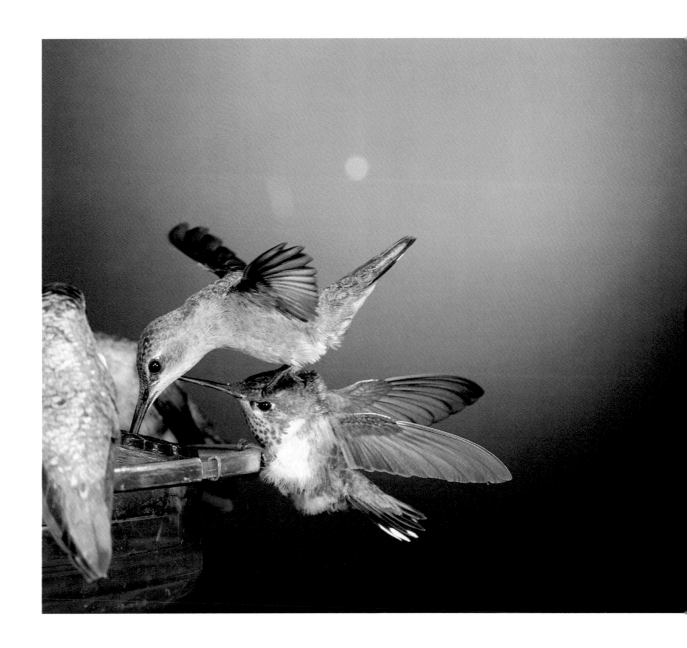

The breeding habitat of these Broad-tailed Hummingbirds is meadow openings near or within woodlands. On the wintering grounds they favor mountain forests that are fairly open, which allows sunlight to penetrate, thus maintaining a diverse understory of flowering plants.

"Can you tell me when I should take my feeder down?" This was the most frequently asked question from callers to the Hummingbird Roundup. It was also one of the first management tips addressed by survey staff advising participants on how and when to feed hummingbirds. The mantra from the Roundup staff was to leave up well-kept feeders until all the birds are gone; and if you want the opportunity to see a wider variety of species, maintain at least one feeder all year long. Many participants believed that by leaving the feeder up, the birds would not migrate on time. Learning from the Roundup that migratory patterns are internally driven by light and day length, many tried the winter-feeding option. Roundup staff knew that overwintering birds are not uncommon in Texas, especially in certain areas with milder climates.

The Roundup surveys revealed that there were quite a few hummingbird hosts who maintained their feeders year-round. In 1994, when the first survey began, 37 out of the 245 participants returning surveys kept hummingbird feeders up throughout the year, and most were well rewarded for it, especially those located in coastal areas with a history of overwintering birds. Of the winter sightings reported that year, there were numerous reports of Rufous, Buff-bellied, Black-chinned, and Ruby-throated Hummingbirds, mostly in Gulf Coast counties, in October, November, and December. Isolated sightings of Broad-tailed

and Calliope Hummingbirds were reported, respectively, in November and December, from participants in Nueces and Victoria counties.

Winter feeders have the greatest success in southern and coastal Texas. Roundup biologists reported in the 1998 *Texas Hummer Newsletter* that winter Rufous sightings had been steadily increasing in the southeastern United States since the 1970s. In fact, that species was now considered a regular winter visitor from West Texas eastward to Florida. In 1997, this increase was corroborated by 116 of the 440 Roundup participants who maintained feeders year-round. Fifty percent of those who maintained their feeders that year were rewarded with hummingbirds, the highest percentage being Rufous. Also coming in were Black-chinned, Buff-bellied, and Ruby-throated Hummingbirds. It was noted that most of these birds were reported from the coastal areas of Texas, with the largest concentrations of participants that year being from Harris, Fort Bend, Brazoria, and Galveston counties (all in the Greater Houston area). The Roundup staff also learned of several feeders in Central Texas hosting birds all winter—in Hays, Travis, and Bexar counties, large human population centers. It is possible that with more feeders and study in these areas (as well as elsewhere in Texas, New Mexico, and Arizona), a greater abundance of overwintering birds might be found. The winters in Central Texas are mild, with only a few short-lived winter blasts.

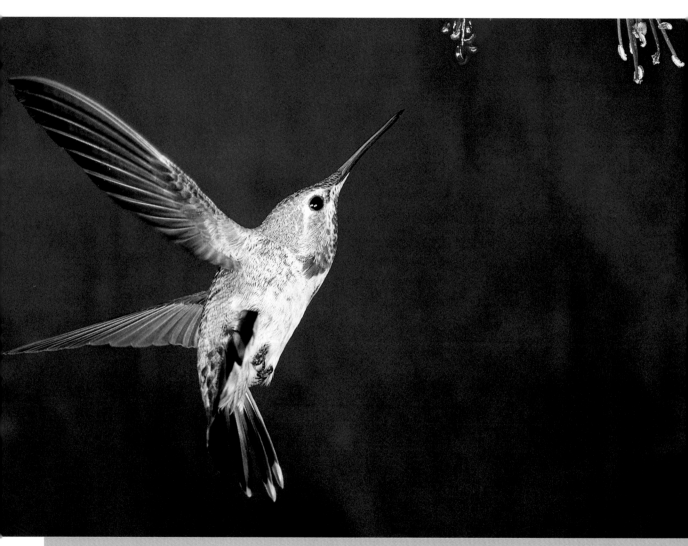

Several species of hummingbirds are remarkably hardy in cold conditions. This female Anna's Hummingbird can be found at cold, high elevations. While roosting through the night, some species of hummingbirds have the ability to slow down their metabolism, which cuts their body temperature in half to conserve energy, a state known as torpor.

Keeping winter feeders and gardens in Texas and other southern locations is not as rigorous as in summer. Flower gardens are rejuvenated with the first fall breezes when the intense summer heat abates, and sugar water stays fresh longer in the fall and winter temperatures. The cooler weather is welcomed, if not embraced, by hummingbird hosts who are ready for a temperature change. With most of the regular birds having moved south, birdwatchers begin looking for any rare winter guests.

Many hummingbird species can survive extreme cold. Those who range in mountains where freezing nights can occur in summer are naturally acclimated and will go into a state of torpor to survive: the hummingbird's physiological body functions slow almost to a stop in an attempt to conserve energy. The bird falls into a sleeplike state with its heartbeat slowing from 1,250 beats per minute to 50, causing irregular breathing patterns or sometimes long periods of no breathing. It is often perched perfectly still and will not fly away, even when approached. Some hummingbirds even fall off their perches during torpor but cannot move until they work up the energy to fly away.

Torpor may help explain the many notes received from Roundup participants who have found hummingbirds they think are dead but later watch them come to life and fly away. Some of the hummingbird species regularly occurring in Texas, New Mexico, and Arizona that are acclimated to cold winter climates include Rufous, Anna's, and the occasional Blue-throated Hummingbirds.

Several Roundup participants who hosted overwintering birds wrote about how they kept their feeders from freezing in an effort to keep wintering birds comfortable. Most Texas freezes are short in duration, especially in southern parts of the state. One participant reported using an electric heating pad wrapped around the feeder. Others would bring feeders in after dark and put them back out in the early morning, whereas others kept replacement feeders ready to hang once a feeder froze. All these winter hummingbird hosts were creative and persistent and seemed successful in their efforts.

For the fourth winter in a row, I have had a Rufous Hummingbird spend the winter here, so I have kept one feeder going all year. The first year when I called the local birding expert in San Marcos, he said the only danger was if the syrup froze—so I placed a heating pad around the bottle and if it does get cold, I plug it in with the thermostat on low. It does not make any difference to them what color the heating pad is, plaid or white.

Hays County, Texas, 1996

Some naturalists speculate that hummingbirds that show up out of their normal range in winter are apt to perish without a naturally occurring food supply or a hummingbird host with a well-kept feeder. Several popular hummingbird books have documented birds overwintering in extreme climates by accessing heated greenhouses or plant rooms. These are isolated incidences of human compassion and not a practice that the Hummingbird Roundup advocates.

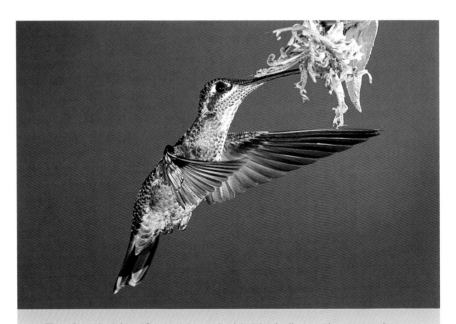

This female Magnificent Hummingbird is similar to the one other large U.S. hummingbird, the Blue-throated, but the former is much grayer in the face. This is a hardy species that occasionally overwinters in canyons within the area covered by this book.

Archie

This is the story of a Broad-billed Hummingbird that my husband named Archie. Archie arrived October 6, 1996, apparently blown from his western Mexico home by a tropical storm. Being an amateur birdwatcher, I knew right away that a most unusual visitor had arrived at the feeder. He hung around for several days, so I decided I'd better get some help in identifying him, although I had had numerous close looks at him and felt that he was a Broad-billed. In a week or so, two San Antonio Audubon Society experts came out and identified him as a Broad-billed. I didn't realize what an exotic visitor I had, until the phone started ringing with many bird enthusiasts wanting to see him.

As time went on, he disappeared for up to 10 days at a time and then as the first northers started arriving, he returned. At first he was rather quiet, but then as he became more familiar with his territory, he became quite a chatterer seemingly following me around the yard telling me all about it. As I write this, we are in the throws of a severe cold spell and into our third day of ice and temperatures in the 20's. I have feared every morning that there would be no more Archie, but so far he's been waiting for me to put out a fresh feeder at dawn. For the rest of the day the feeders are changed at least every hour.

I am hopeful that Archie will survive the rest of the winter and eventually find his way back to his home. His beautiful turquoise and bluish plumage and red bill have been a real joy to me, and I wanted to share this birding adventure with others.

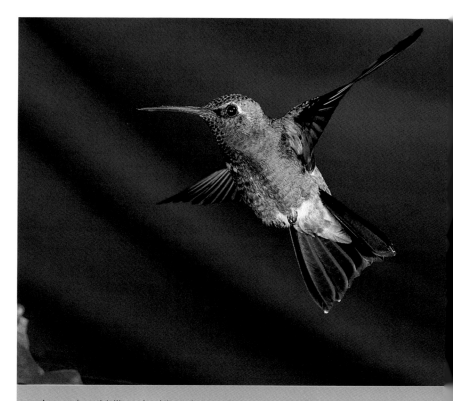

A coral red bill and a blue throat that meets a glittery green and blue breast are the distinguishing features of the male Broad-billed Hummingbird. Iridescent plumage makes hummingbirds some of the most exciting species to observe in nature. The observer must be at the proper angle to the bird and the light source in order to get the maximum brightness of color. Otherwise, iridescent feathers can look dull or blacked out.

Migratory Behavior

Almost every species of hummingbird found in the United States, and certainly all those from Canada, are migratory, leaving for warmer climes to the south in winter and returning again during the springtime. Very few hummingbirds avoid some kind of trek south or into the lowlands for the winter, where more favorable temperatures and adequate food supplies await them. Most individuals cross the Tropic of Cancer, which cuts through central Mexico, thus qualifying them as Nearctic-Neotropical migrants (breeding to the north of that line yet wintering to the south of it). Most of these hummingbirds spend the winter in southern Mexico, unlike some of the truly long-distance Nearctic-Neotropical migrants that winter in South America. None of our North American hummingbirds ventures as far as the South American continent; only the Ruby-throated gets close by wintering (very rarely) as far south as Panama.

In the North American hummingbird world, Rufous and Ruby-throated Hummingbirds have a truly long annual trek. Many Ruby-throateds, for example, cross five hundred to six hundred miles of open water over the Gulf of Mexico during migration. Although Rufous Hummingbirds do not face such large bodies of water, some have been noted to travel as far as two thousand miles between breeding and wintering ranges. Rufous and Anna's Hummingbirds may also undertake the unique behavior of migrating and overwintering east-ward in the United States, instead of pushing southward into Mexico and the rest of Central America. This behavior occurs especially along the Gulf Coast states, which typically experience mild winters.

Several species of western hummingbirds follow what is known as an elliptical migratory path. Their route can be described as shaped almost like a football standing on one end rather than as a straight north-south highway. This route typically involves birds using the more westerly route up the west coast of North America when northbound and using the more easterly route along the front range of the Rocky Mountains when headed south. The elliptical migrants involve mostly the breeding species that inhabit mountains and canyons, such as Calliope, Rufous, and Broad-tailed Hummingbirds, and possibly a few other species, which explains why some species, such as the Calliope Hummingbird, appear in greater numbers in eastern New Mexico and western Texas in the fall rather than the spring.

There are increasing reports of Buff-bellied Hummingbirds from the Post Oak Savannah ecoregion of Texas (specifically west and northwest of Houston). This is well north of the nearest breeding population on the Coastal Bend. These individuals are either wandering north after breeding or expanding the normal range of this species northward. The Victoria County area of Texas seems to be approximately where resident birds to the south are separate from seasonal birds to the north. More investigation of Buff-bellieds is needed, especially to confirm any nesting in the Post Oak Savannah ecoregion.

The final migration spectacle must be considered the most impressive. Tens or even hundreds of thousands of Ruby-throated Hummingbirds stack up along the Gulf Coast in fall. It is unclear how many individual Ruby-throateds decide whether to cross the Gulf (as trans-Gulf migrants) or hug the coast around the Gulf (as circum-Gulf migrants). It is clear, however, that in the springtime when the mad dash to go north to the breeding grounds occurs, many Ruby-throateds take the shortest route across the vast Gulf of Mexico.

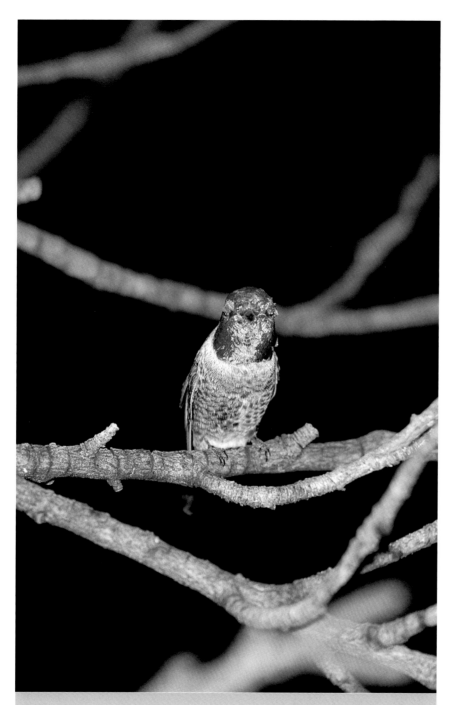

Injuries or diseases are almost always fatal to hummingbirds. These masters of flight must be in prime condition to actively forage and migrate. Injury happens most often during aggressive fighting bouts, which could explain what happened to this male Anna's Hummingbird.

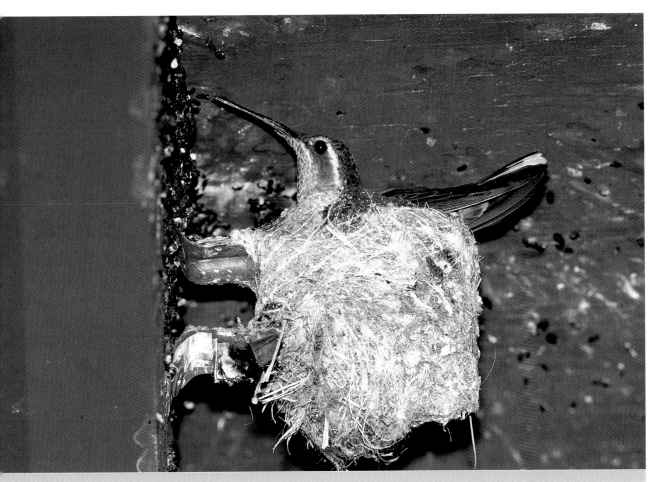

This female Blue-throated Hummingbird is incubating eggs in a nest that she built atop a completed and successful nest used earlier in the same breeding season. Rearing a second or even third brood within a breeding season is not unusual in the hummingbird world. This nest was placed under the eave of a house in southeastern Arizona. While incubating, adult hummingbirds simply lift their tails to defecate, ejecting the feces with great force. All the dark blobs stuck to the wall in front of and around this bird are such droppings.

Photographing the Hummingbirds

By Sid and Shirley Rucker

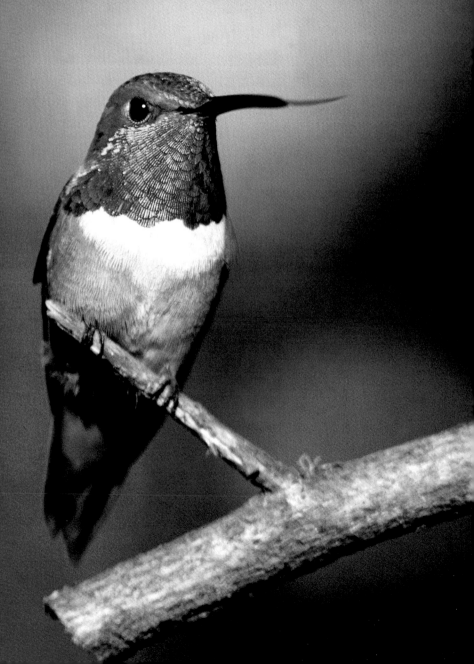

We were flattered when Texas Parks and Wildlife Department personnel asked us to provide the photography for this book on hummingbirds. We dedicated the best part of four years to photographing these birds. Our quest for the species seen in Texas led us out of Texas and into New Mexico, Arizona, Montana, California, and Mexico.

We are indebted to the many people who graciously opened their homes, yards, and hearts to us in this endeavor. Without their help, we would not have been able to successfully complete this project.

The photographs in this book involved unrestrained, free-flying hummingbirds. We experienced less-than-ideal conditions in photographing these birds. Temperature extremes ranged from over one hundred degrees at lower elevations to the thirties at eight thousand feet and above. We battled high winds, sudden rainstorms, stinging and biting insects, poison ivy, ants and bees harassing the hummingbirds, and occasional equipment failures. Once in Mexico, we were confined to our location for three days because of rain and high water, and there were no hummingbirds to photograph. We frequently were out photographing by 5:00 A.M. and taking down our photo setup as late as 10:00 P.M. Some nights we were up until 2:00 A.M. when photographing the nectar-feeding bats coming to our feeders. These inconveniences pale when compared to the joy we felt observing and capturing these fascinating little birds on film.

Setting Up to Photograph

Our first step is to set up our equipment and feeders in an area that hummingbirds are known to frequent. As they become accustomed to our presence and photographic

The tongue is only partially extended in this male Rufous Hummingbird. The breeding range of this species extends as far north as southern Alaska, and wintering occurs as far south as western Mexico (north of the Isthmus of Tehuantepec). Along with the annual trek of the Ruby-throated Hummingbird, this is likely one of the greatest distances traveled by any hummingbird species.

This photograph shows the photographers' field setup. All the photos in this book by Sid and Shirley Rucker of Texas are of free-flying (never caged) hummingbirds. Their custom-made flash unit consists of five flash heads that can be fired at either 1/10,000 or 1/20,000 second. These high speeds are necessary to freeze the fast-beating wings. At slower speeds, the wings appear blurred.

setup and are feeding regularly from the feeder we plan to use, we cover all the ports with tape, except one, forcing them to feed where we have aimed the camera and flashes. The number of hummingbirds coming in to feed determines how many feeders we leave up; if only a few birds, we take down all the other feeders, but if there are many hummingbirds, we leave up other feeders to ensure that they have ample food. Looking through the camera viewfinder, we see the size of the bird in the frame, determine whether it is too small or large, and make final adjustments necessary to render a pleasing composition of hummingbird, flowers, and background.

Equipment and Techniques

Our Nikon 35 mm cameras have a flash sync speed of 1/250 second. Any slower sync speed increases the chances of ghosting and images that are not sharp. We use single-frame shooting as opposed to continuous-frame shooting to allow the strobes time to recycle to full power between shots. We manually focus rather than use autofocus because it is difficult to keep the autofocus sensor on the bird's eye and to correctly frame the bird.

Our lens of choice is a 200 mm micro when the hummingbirds will allow us to be as close as four feet because this lens renders the greatest detail. When the birds will not tolerate our presence that close, we use a 600 mm lens (300 mm f/2.8 with a 2x doubler) that focuses to about ten feet. We stop down our lenses to f/16 or f/22 for the maximum range of acceptable sharpness, which is about one inch. A sturdy tripod with a ball head gives the steadiness and flexibility needed to frame the bird and focus on its eye.

The secret to stopping wing motion is using high-speed electronic flash. We use a custom-made unit with five flash heads that fire at 1/10,000 or 1/20,000 second. Four flashes illuminate the bird and are placed seventeen inches from it. Three of these are aimed directly at the bird: one is above or below the camera in line with the bird; the other two are placed on each side of the camera at approximately twenty-degree angles. The fourth flash is a highlight aimed down at about a seventy- to eighty-degree angle to give greater separation between the bird and the background. The fifth flash illuminates the background to prevent an unnatural black background. All five flashes are on individual light stands with ball heads for easy adjusting. A handheld light meter determines basic exposure.

Patience and a comfortable chair are just as essential as all the cameras and lenses when photographing hummingbirds. The camera and flashes are all pointing at a single feeder waiting for the hummer. A colored mat board used as the backdrop gives a soft, pleasing background to the photographs.

Photographic Notes

Photographing hummingbirds requires a certain amount of basic equipment and technical knowledge. We cannot, however, overlook the role that chance, good luck, and serendipity play in photographing them. Being in the right place at the right time, being flexible, and seizing an unexpected opportunity made possible several pictures in this book.

Backgrounds can be a mat board, a piece of cloth, a bush, flowers, or any combination thereof. We use different colors and designs for variety and try to use colors and flowers to complement the particular hummingbird we are photographing. A sunshade is used over the feeder to reduce ambient light and ghosting, with the darkest side facing the setup.

The techniques described were used when we photographed a hummingbird at a feeder or as it flew to and away from the feeder but was still within the flash range. The method changes when photographing a bird feeding at wildflowers or perched on a limb. In these cases, we follow the hummingbird with a handheld camera and use one teleflash. The shutter speed is still set on 1/250 second, and the lens aperture will usually be f/11 or f/16, depending on the distance we are from the hummingbird.

Time, patience, and shooting a lot of film are the key ingredients in hummingbird photography. We have taken many slides of hummingbirds with heads or tails cut off the birds, out-of-focus birds, or no birds at all . . . our trash can runneth over! But then we have also experienced those times when everything worked out and we got that outstanding image of a beautiful hummingbird, making it all worthwhile.

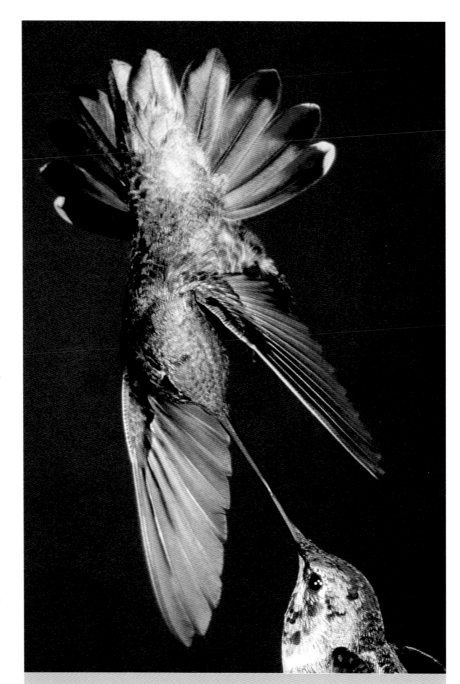

What are the chances of getting the bills of these two Anna's Hummingbirds to line up perfectly as they battle over a food source? During the breeding season, female hummingbirds maintain territories like the males. Only female hummingbirds, however, tend to the nest and young.

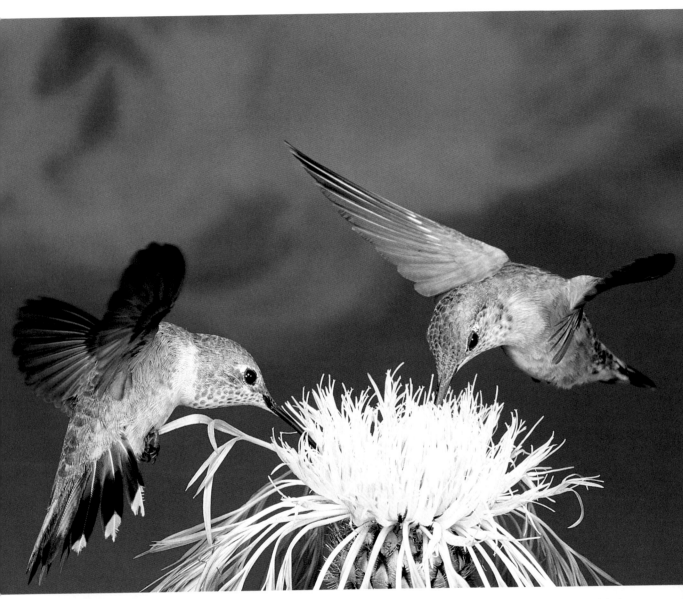

Thistle is always a favorite among hummingbirds, especially these female Broad-tailed Hummingbirds. The rufous color in the wings, flanks, and tail helps narrow the identification to a member of the genus *Selasphorus*. Wing flapping in hummingbirds, as seen here with the twisted wing, is not a simple up-and-down motion as it is in so many other birds. Instead, it is a somewhat circular motion that takes the shape of a figure eight. This motion allows the birds to fly in just about any direction, including backward and sideways, which together are impossible actions in other groups of birds. The camera was set at 1/250 second and the flashes at 1/20,000 second to give us insight on the wing beats of a hummingbird that enable the act of hovering.

Iridescence

Hummingbirds are often frustrating to identify because of their fast-flying antics. Additionally, sunlight can play tricks with the colors in some parts of (mostly) the male hummingbird. Some observers take for granted that the color of the chin and throat (or gorget) in the male hummingbird can simply be matched to a field guide picture, thus enabling identification of the species. Lighting and angles, however, can seriously affect the colors, making it very important to avoid using them as the sole means for species identification. Instead, several characteristics of each hummingbird should be studied.

Interference is the optical process that creates iridescence in hummingbirds, much as it does to a soap bubble or a slick of oil on water. Waves of light are often distorted, which can create a spectral rainbow of colors. For this reason, the gorget can appear to be different colors depending on the angle of refraction (that is, a male Ruby-throated's gorget can appear topaz, red, or black just with a turn of its head). Oftentimes, the gorget might not be easily seen well, so other features of the bird must be examined in order to make the identification. Study the plates, photos, and species accounts in this book for the best distinguishing characteristics. With a little more knowledge about the species applied to careful observations, one can become more confident in identifying birds. There is no substitute for the study of hummingbirds, or any bird, in the field.

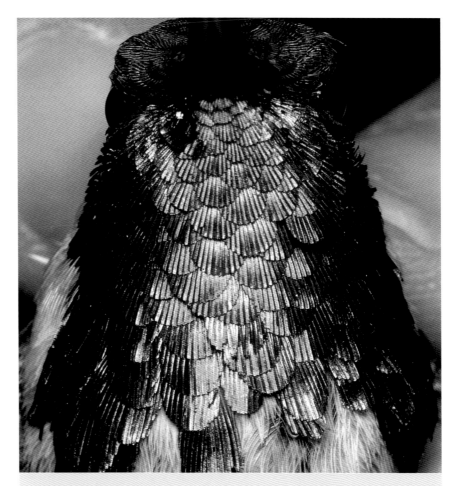

Notice the vibrant color in this close-up of a handheld Lucifer Hummingbird during a licensed banding study. At certain angles, light on iridescent feathers can play tricks on even a keen observer, and it is best not to rely solely on these bright colors when identifying a hummingbird.

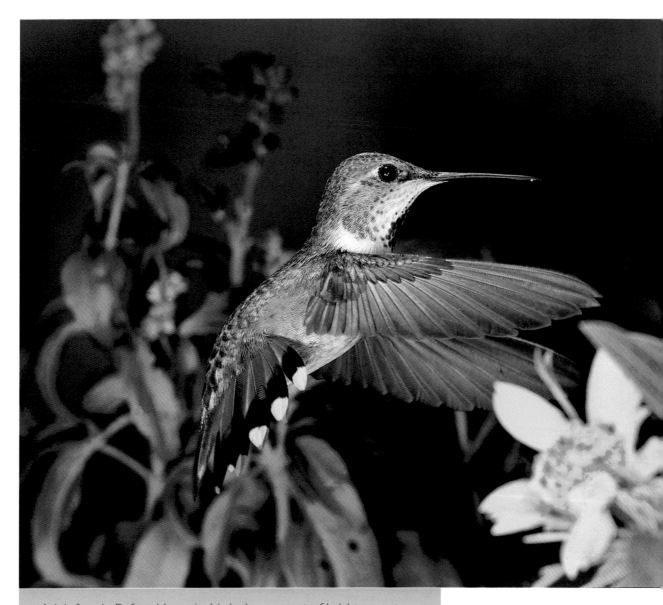

Adult female Rufous Hummingbirds show a spot of bright gorget color in the lower midsection of the throat, but that spot appears blacked out at the angle of this individual. First-year males look very similar, superficially, to adult females. This species is quite hardy in winter and is the most widespread of the wintering species in the United States. In the Gulf Coast states, for example, Texas, the number of overwintering records is increasing. Many individuals of this species appear to make an odd west-to-east migration in fall instead of north-to-south.

In his 1960 book, A Field Guide to the Birds of Texas and Adjacent States, *the late ornithologist Roger Tory Peterson wrote the following about the bird life of the Lone Star State: "Texas, in keeping with its reputation for bigness, can boast the largest avifauna of any of the 50 states." This statement is equally true of the tally of hummingbird species. Texas has eighteen species of hummingbirds documented within its borders—more than any other state in the United States. Arizona and New Mexico are tied for second place, each with seventeen species.*

A rich diversity of hummingbird life in a variety of habitats awaits nature enthusiasts residing in or visiting these three southwestern states. The photographs and illustrations in the species descriptions that follow will help any hummingbird lover identify these fast-flying birds. The abundance graphs at the bottom of the page allow a quick glance at seasonal occurrence. Many species are highly migratory and have strong seasonal ties, so the date of observation can aid in hummingbird identification. The range maps—covering Texas, New Mexico, and Arizona—are mostly "broad brush strokes" on a map peppered with documented records of vagrancy. Together, these tools should help guide observers through the wonderful world of hummingbird watching in the United States.

Hummingbirds by State

	TX	NM	AZ*
Allen's Hummingbird	X	X	X
Anna's Hummingbird	X	X	X
Berylline Hummingbird	X	X	X
Black-chinned Hummingbird	X	X	X
Blue-throated Hummingbird	X	X	X
Broad-billed Hummingbird	X	X	X
Broad-tailed Hummingbird	X	X	X
Buff-bellied Hummingbird	X		
Calliope Hummingbird	X	X	X
**Cinnamon Hummingbird		X	X
Costa's Hummingbird	X	X	X
Green Violet-ear	X	X	
Green-breasted Mango	X		
Lucifer Hummingbird	X	X	X
Magnificent Hummingbird	X	X	X
Plain-capped Starthroat			X
Ruby-throated Hummingbird	X	X	X
Rufous Hummingbird	X	X	X
Violet-crowned Hummingbird	X	X	X
White-eared Hummingbird	X	X	X
TOTALS:	18	17	17

*Arizona also has an historical record of two Bumblebee Hummingbirds from 1897.

**The Cinnamon Hummingbird is considered an extreme vagrant and is not included in the species accounts that follow.

Potential Hummingbird Vagrants To The United States

Species that occur just south of the U.S.-Mexico border yet could stray northward (any of these could appear in these southwestern states):

Amethyst-throated Hummingbird	?	—	—
Azure-crowned Hummingbird	?	—	—
Canivet's (Fork-tailed) Emerald	?	—	—
Wedge-tailed Sabrewing	?	—	—
White-bellied Emerald	?	—	—
Xantus's Hummingbird	—	—	?

Note: A question mark means that a species is more likely to occur in this state than in the other two states.

Hummingbirds of Texas with Their New Mexico and Arizona Ranges

Map Legend

Summer

Migrant

Winter

Year-round resident

Occasional occurrence

Occasional only in winter

Occasional in fall and winter

● Extralimital record(s)

▲ Extralimital breeding

Seasonal Abundance Graphs Legend

One or more records during this month, but generally not expected to occur at this time.

Month

Unusual, but expected in proper season, range, and habitat

Expected in proper season, range, and habitat

J F M A M J J A S O N D

Allen's Hummingbird *Selasphorus sasin*

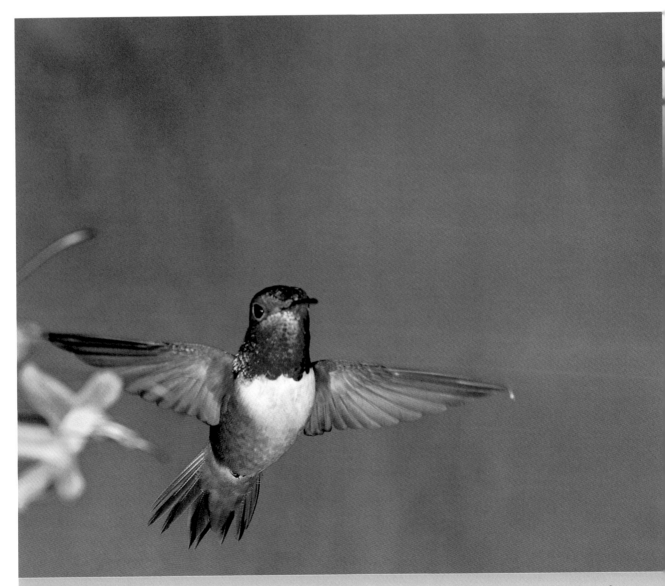

Rarely do photographs of free-flying Rufous or Allen's Hummingbirds aid in the difficult identification of these look-alikes. Certain tail feathers, however, are noticeably thinner and spiky on the male Allen's, such as this one. One of the best ways to confirm the identification is with measurements, which must be taken by a licensed bird bander.

The identification of this species and the look-alike Rufous Hummingbird is extremely challenging, one of the most difficult among North American bird identifications. Specimen or banding records (that is, from handheld birds) are usually necessary to distinguish the two. As of 2003, there were more than 30 documented records in Texas, mostly from the winter months, and only a handful of documented records for both Arizona and New Mexico. Arizona falls directly within the migratory path of this species as it annually moves back and forth from its tiny known wintering range in central Mexico (certainly the smallest winter range of any U.S. hummingbird). Caution in identification, however, is heavily advised when distinguishing this bird from the more common and widespread Rufous Hummingbird. Most observers are going to see many more Rufous Hummingbirds before confirming an Allen's. A cautious observer should not be ashamed at making the identification to the pair of species simply known as "Rufous/Allen's." This is commonly accepted in the birding community with other look-alike pairs such as accipiters, dowitchers, and scaup.

Like the Rufous, this species is a shiny, coppery color below with green upperparts. When in the hand (that is, during licensed bird banding), the thin, pinlike outer tail feathers are the deciding factor between these two species. The same feathers in the Rufous are broader, which is a more typical hummingbird tail shape. This feature, however, is difficult to assess in the field because these small, fast-moving hummingbirds do not usually allow for close, detailed inspection of the tail.

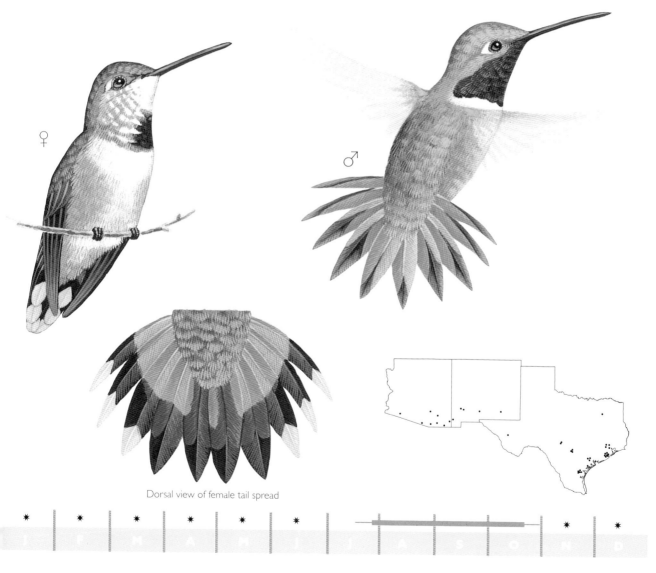

Dorsal view of female tail spread

71

Anna's Hummingbird *Calypte anna*

One of only a handful of North American birds named for a woman, Anna's Hummingbird was named for the wife of a French prince. Of all hummingbirds, this species is most often confined to the United States, with a range that barely reaches southwestern Canada in the north and only small portions of three or four states of northwestern

This immature male Anna's Hummingbird is shown during flight as its wings were in the downward part of a wing beat, which seems to resemble the strong flapping of a much larger bird, such as a raptor. In fact, hummingbirds rapidly move their wings in a figure-eight pattern. Photographing free-flying hummingbirds in this way can provide insight into how these jewels have mastered hovering.

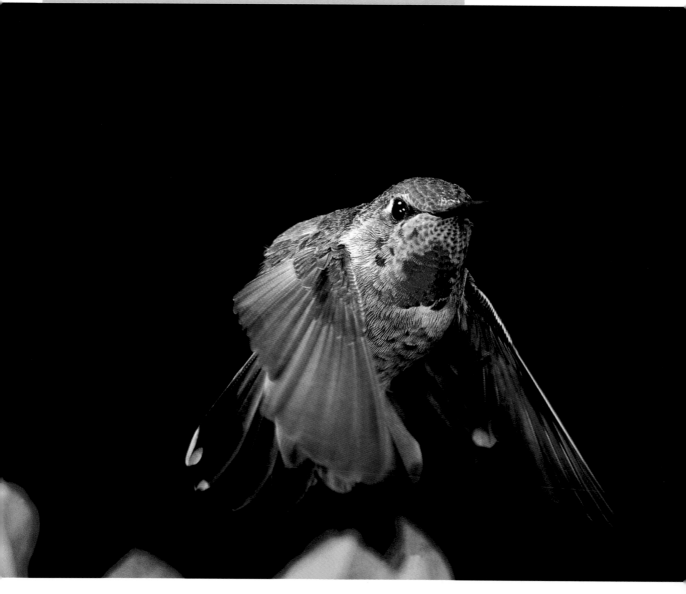

Mexico in the south. Anna's is found in a variety of habitats from low to mid-elevations in both open country and urban areas. From far western Arizona to the Pacific Coast, this is a year-round hummingbird. This species breeds in Arizona and the southwestern corner of New Mexico, but two documented records in Texas (El Paso and Jeff Davis counties) are the easternmost nesting records. Birds have been known to overwinter just about anywhere in the three states as well as eastward through other Gulf Coast states. Anna's Hummingbird is perhaps the most regular wintering hummingbird in southern New Mexico and West Texas.

Males have a brilliant pink to red "shielded" look to the head with a white spot behind the eye. As with other species, the magenta gorget may appear black. Some females sport a tiny red patch in the center of the throat or faint dusky streaks all along the throat, but some are very plain throated. A noisy songster for a hummingbird, it usually emits a lot of warbles and squeaks when perched. This bird tends to hold its tail still and steady while hovering.

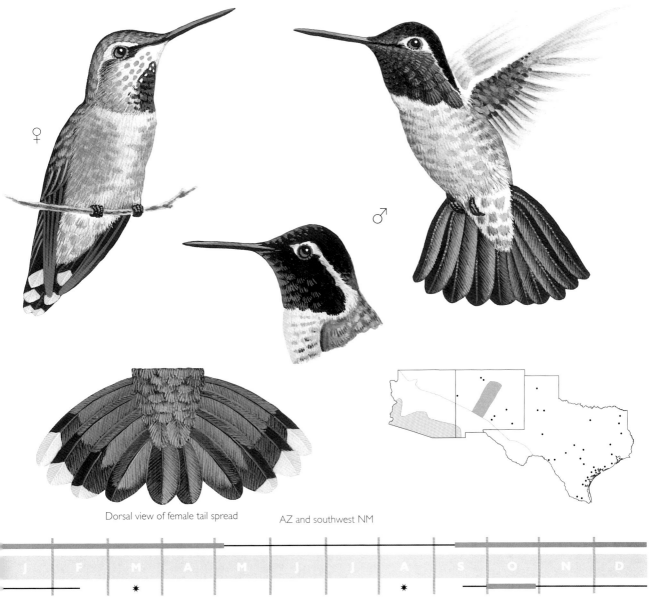

Dorsal view of female tail spread

AZ and southwest NM

J F M A M J J A S O N D

TX and most of NM

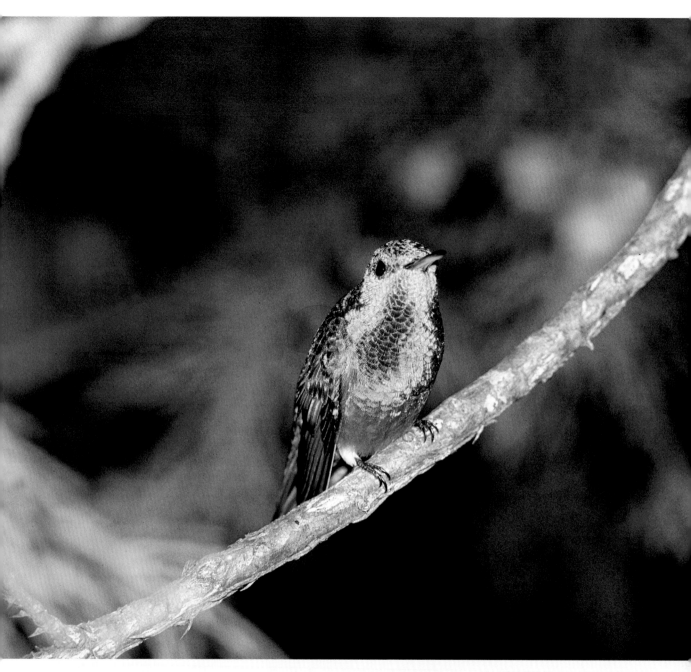

Observing a Berylline Hummingbird is an exceptional treat anywhere in the United States. The camera's flash has caused the brilliant green underparts to reflect off the bill. Most of the U.S. records come from southeastern Arizona, but since the late 1990s there has been a growing number of sightings in the Davis Mountains of West Texas, where the species might be a rare inhabitant.

Berylline Hummingbird *Amazilia beryllina*

The word *berylline* can be translated as "emerald green," the predominant color of this hummingbird's head and throat. The bird prefers mixed conifer-oak woodlands of canyons and foothills in upper elevations from Mexico to Honduras. This species has bred in southeastern Arizona on occasion, and it makes at least an annual appearance there for birders to chase. In New Mexico, this species has been found only in the southwestern corner once or twice. The bird was first spotted in Texas in 1991 in Big Bend National Park, and by 2003 there were five additional state records, all from cool, wooded canyons in the Davis Mountains— four during late summer and one in spring.

The Berylline Hummingbird looks similar to the Buff-bellied Hummingbird, but the Berylline has a gray belly, dark upper tail coverts, and a noticeable rusty flash from the wings while in flight that is also visible when perched. The sexes are quite similar, but the male is more glittery green on the throat and breast, replaced with a duller grayish green on the female. The bill is slightly drooped and darkish with hints of a reddish tone.

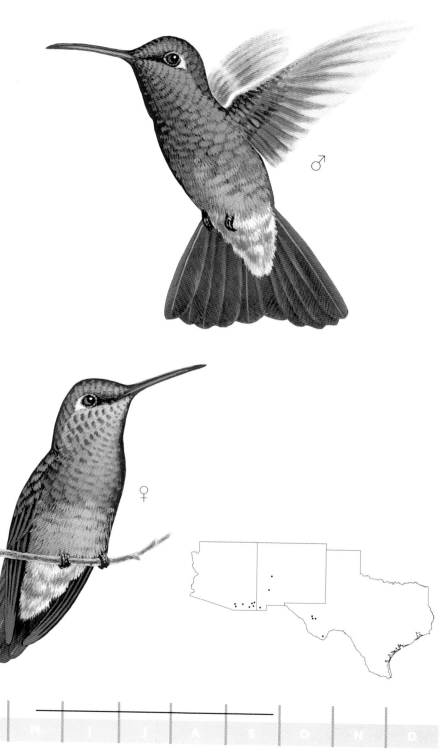

Black-chinned Hummingbird

Archilochus alexandri

The Latin modifier *alexandri* refers to a French doctor who practiced medicine in the 1840s in Mexico but was also an amateur ornithologist who sent bird specimens back to his homeland. This is the most common and widespread species of hummingbird in the western part of the United States. The bird is found from the southern part of British Columbia south through the western part of the United States down

Unusual view looking down on the twirling wings, upperparts, and spread tail of a female Black-chinned Hummingbird. Typically, in short bursts or short distances, hummingbirds can attain speeds of more than fifty-five miles per hour. They are some of the fastest straight-line fliers in the bird world.

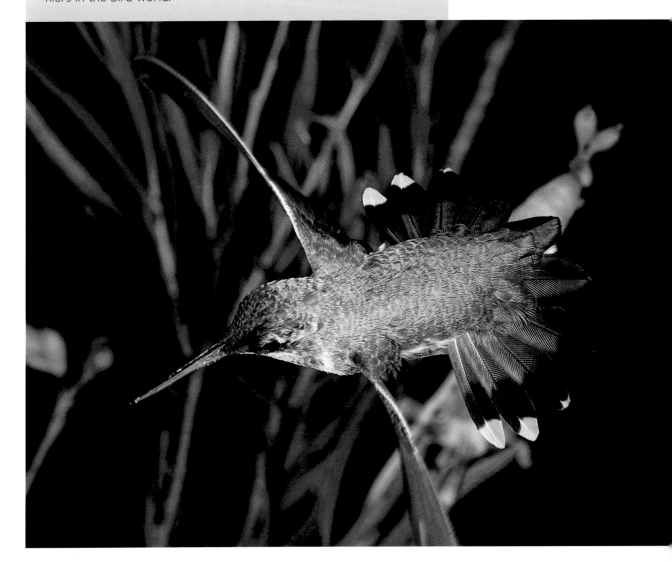

to central Mexico. The range of the Black-chinned Hummingbird can overlap with that of its close relative, the Ruby-throated, especially in fall migration in the central part of Texas, but they do not breed in close proximity to one another. In the narrow area where their breeding ranges overlap in Central Texas, the Black-chinned prefers drier, more open areas such as mesquite or oak savannas; whereas the Ruby-throated prefers wetter, forested edge habitat, such as riparian areas.

A male hummingbird with a black throat should not be immediately identified as a Black-chinned. Use caution when making such a determination because the identification between this species and the closely related Ruby-throated (especially the females) is an extremely difficult one. Some angles of view can make the male's gorget look blacked out on both species, thus making the two difficult to differentiate until light is finally refracted off the throat. Watch for hints of purple in the throat to conclude that it is indeed a Black-chinned (versus the topaz-to-red throat of the male Ruby-throated). See the Ruby-throated Humming-bird account for more details on telling these two look-alikes apart.

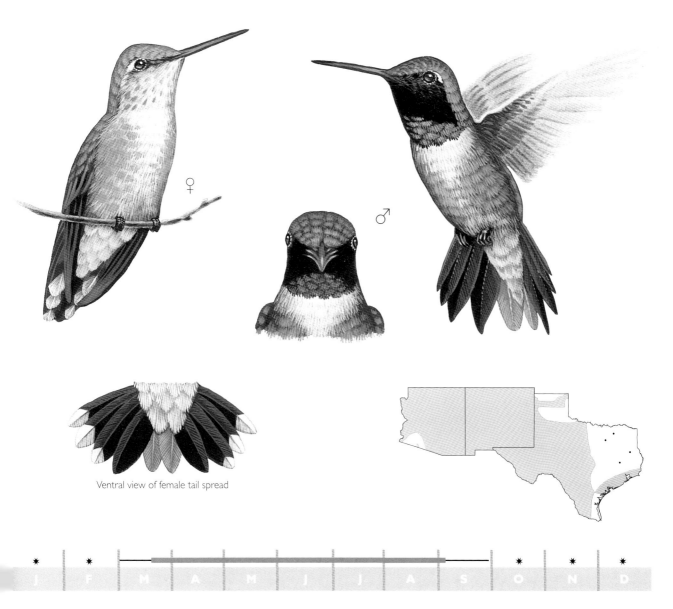

♀

♂

Ventral view of female tail spread

Blue-throated Hummingbird *Lampornis clemenciae*

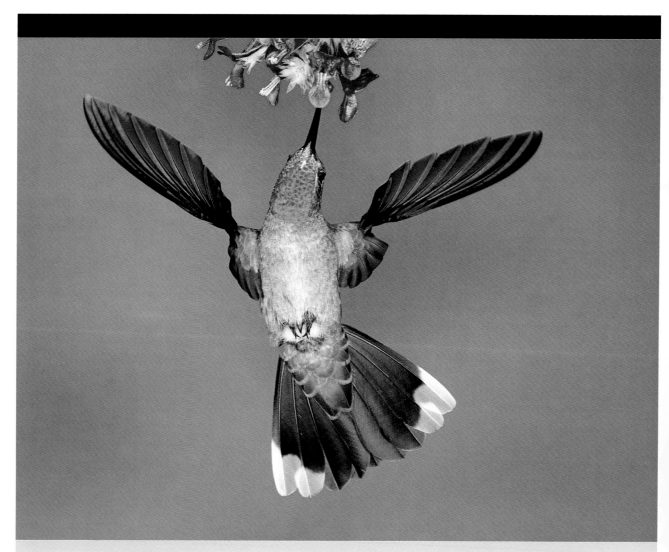

The male Blue-throated Hummingbird is the only U.S. hummingbird with a distinctly blue chin and throat that ends abruptly against a gray breast. Migratory male hummingbirds reach the breeding grounds before the females in order to stake their claim to the best territory. A hummingbird territory is an amorphous area that ranges in size (often smaller than a football field) and must include ample food sources, which are vigorously guarded.

Predominantly a Mexican species found as far south as the state of Oaxaca, this species breeds in the far southern corners of the three-state area covered in this book. The species prefers mountain streams lined with large trees, such as pine, cypress, and oaks.

This very large hummingbird has a dusky gray face and underparts, a white stripe behind the eye, and a metallic blue throat on the male (dusky gray on the female). The overall first impression of this bird is that it is long, gangly, and mostly dull colored. The wings beat a tad slower than those of other U.S. humming-birds, which gives the appearance of slow-motion flapping. The bird fans its tail in flight, showing the large white tips to the outer tail feathers. No other U.S. hummingbird sports such a well-defined blue chin and throat patch that stops abruptly at a gray chest (although this blue gorget can be difficult to see at most angles).

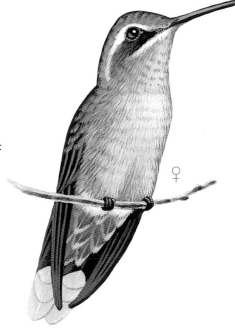

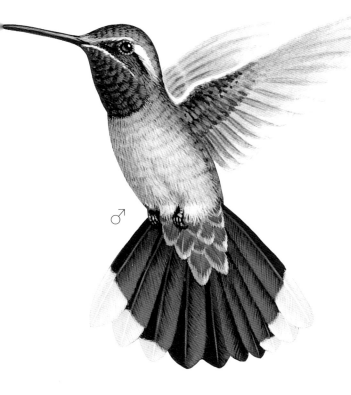

Dorsal view of female tail spread

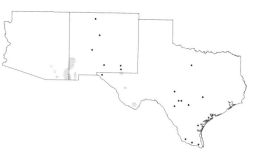

Broad-billed Hummingbird *Cynanthus latirostris*

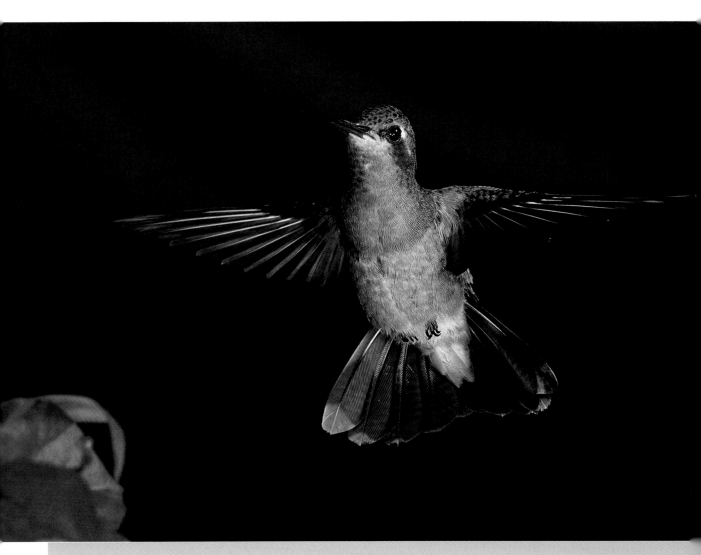

This female Broad-billed Hummingbird has a pinkish bill, especially at the base, and she lacks the full-body iridescence of her male counterpart. Along with the bill, the gray spot behind the eye and a gray face mask are helpful in the identification of females of this species.

This is an expected, annual breeding species in the foothills and canyons of southeastern Arizona and southwestern New Mexico. This bird is quite rare in Texas, however, with fewer than sixty documented records, mostly in spring and winter, and no documented breeding records. Found only in the southwestern United States to central Mexico, this species does not occur farther south than the Isthmus of Tehuantepec.

Broad-billeds are named for the broad base of their bills, which is best seen during close frontal or partially frontal views (see page 7). Under favorable lighting, adult males are arguably one of the most colorful hummingbirds in the United States, with a predominant flash of glittering blue or violet blue and green. The most recognizable features include a fairly long, coral red bill with black tip (brighter red in adult males) and

a noticeably notched, dark-colored tail (in males). The male's gorget often appears brilliant blue, and this color continues ventrally down as flecking onto a bright green breast. This hummingbird's behavior of tail flipping while hovering is helpful in identifying it. Females, with their red bills, also have smooth gray underparts and a long, thin white eyebrow that help distinguish them from most other female hummingbirds.

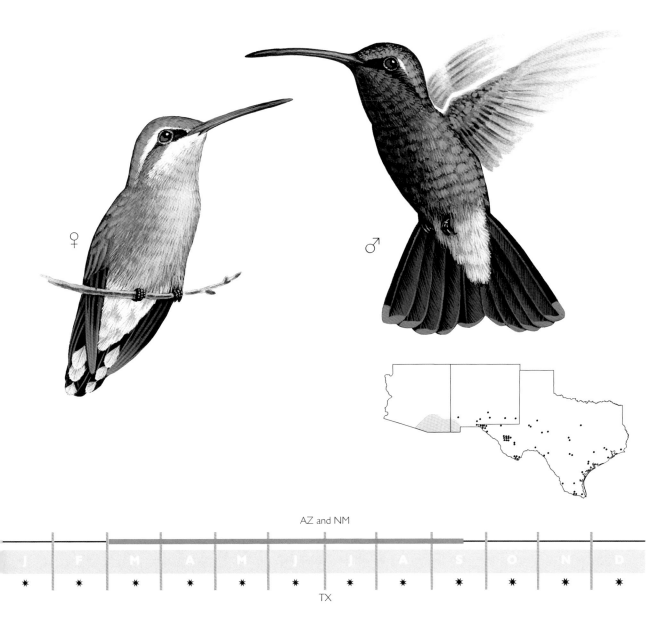

AZ and NM

J F M A M J J A S O N D

TX

These female Broad-tailed Hummingbirds are perched and interacting on a sotol. Along with their closest relatives, swifts, hummingbirds belong in the taxonomic order Apodiformes, which means roughly "without feet." This reference is more to the group's perceived weak feet, not lack thereof. All species in the order have functional feet.

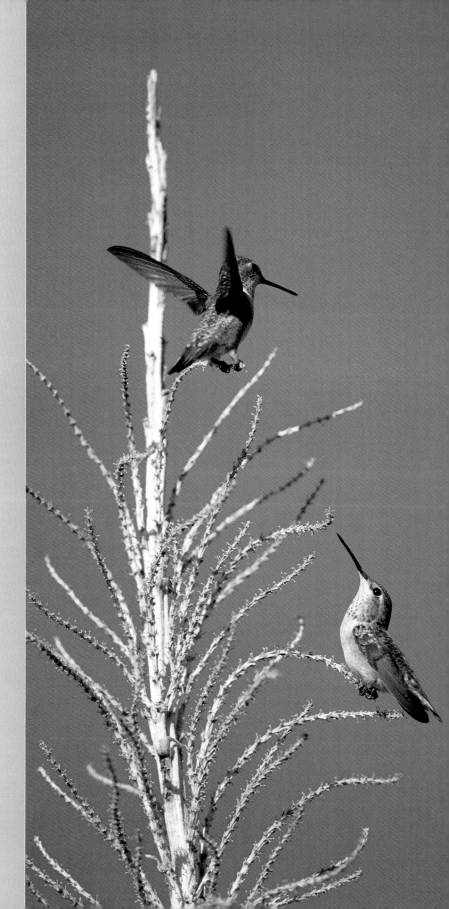

Broad-tailed Hummingbird *Selasphorus platycercus*

The spread tail does appear broad relative to that of other species of hummingbirds, but this is certainly not the field characteristic that an observer should look for. The tail is long, though, and extends beyond the wing tips when the bird is at rest. The humming noise produced by the wings in the males of this species is unique and loud, which often aids in first detecting the bird's presence.

The Broad-tailed is often misidentified as a Ruby-throated Hummingbird, but the breeding ranges of the two species never overlap, and the geographic location will help make the identification.

The Broad-tailed breeds in a narrow range of elevation among the mountains of the Desert Southwest, but it can occur at just about any elevation during migration.

Males have a rose gorget and a distinctive pale line from the chin through the eye and face. The flanks of the male are both green and buffy. Females, like the males, have green backs but buffy flanks, dusky spots on the cheek, and a pale (sometimes broken or incomplete) eye ring.

♀

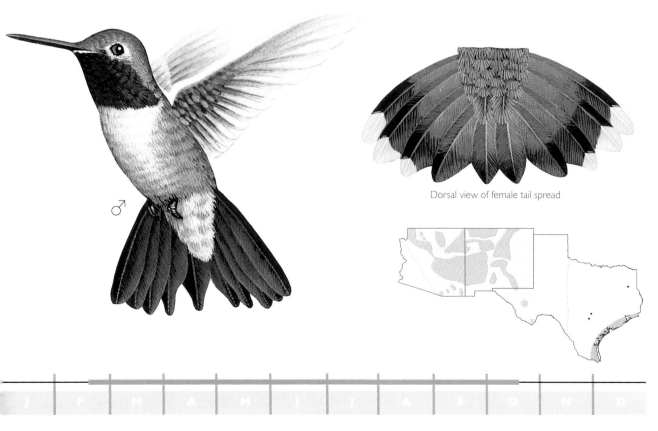

♂

Dorsal view of female tail spread

Buff-bellied Hummingbird *Amazilia yucatanensis*

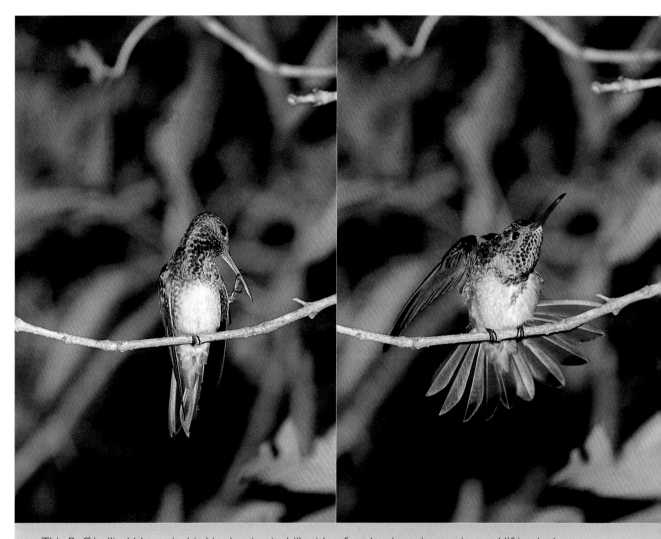

This Buff-bellied Hummingbird is cleaning its bill with a foot by dropping a wing and lifting its leg over and around the wing instead of up and under it. Then the bird stretches. This large, aggressive hummingbird has a red bill, dark green head and upperparts, buffy underparts, and a rusty tail. Buff-bellieds are expanding their range northward into the Brazos River Valley of east-central Texas. In winter, Buff-bellieds regularly wander up along the Gulf Coast into Louisiana and sometimes beyond. Breeding in the United States, however, does not seem to take place north or east of the Lower Guadalupe River Valley on the central Texas coast.

Of the three states covered in this book, Texas is the only one where this hummingbird has been found. Once known as the Fawn-breasted Hummingbird, this species is not known from any points south of the Yucatán Peninsula of Mexico and Belize. The bird prefers dry woodlands of lower elevations of the Gulf Coast slope. The northernmost breeding occurs into the central Coastal Bend region of Texas. From here, postbreeding wandering and overwintering occurs northward along the remainder of the Texas coast and continues eastward.

This is a large, aggressive species, which is typically the dominant hummingbird on feeders and flowers in an area. In southern Texas, it relies heavily on Turk's cap (*Malvaviscus*), which flowers in late summer and early fall, and ball moss (*Tillandsia*), which flowers from early summer to early fall. The Buff-bellied resembles the Berylline Hummingbird but has a tan belly and no rusty flash in its darkish wings. The bill is slightly drooped, quite reddish, and tipped in black. Males and females are similar.

An old record of two Rufous-tailed Hummingbirds (*A. tzacatl*) from southern Texas could possibly have been a misidentification of the Buff-bellied. There is no specimen or proper documentation for the Rufous-tailed in the United States, where it is not expected to occur.

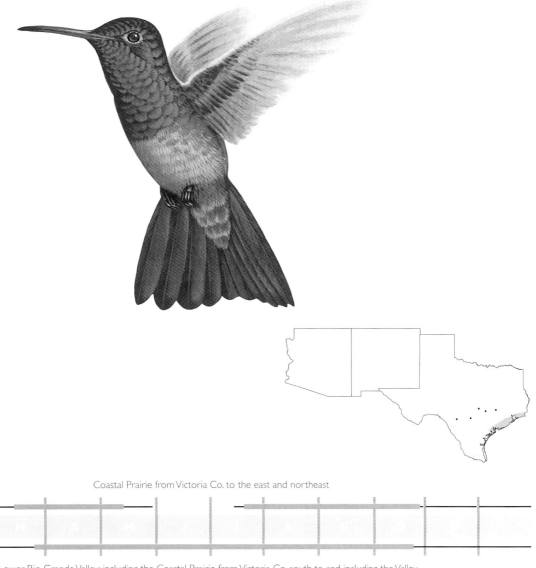

Coastal Prairie from Victoria Co. to the east and northeast

Lower Rio Grande Valley; including the Coastal Prairie from Victoria Co. south to and including the Valley

Calliope Hummingbird *Stellula calliope*

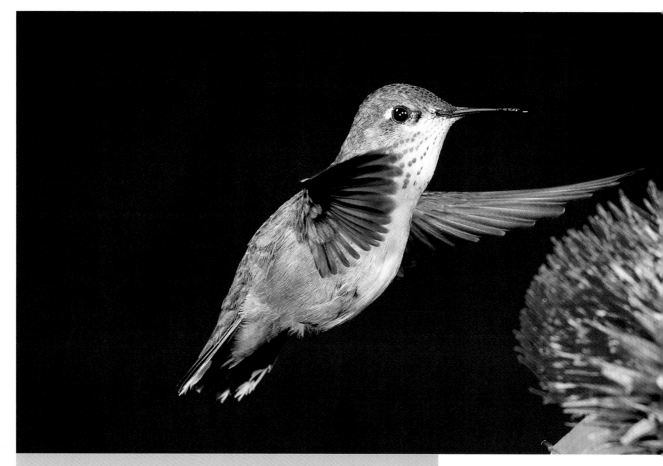

The name "Calliope" implies a musical ability, which is quite misleading for the hummingbird by that name. Hummingbirds do not have the ability to sing, as a songbird does, but they can and do vocalize regularly, especially the males during the breeding season. The Calliope Hummingbird, such as this female, is the smallest U.S. hummingbird, and even its bill is petite.

The word *calliope* refers to a wheezy, organlike musical instrument. Essentially found west of the Rocky Mountains from southwestern Canada to central Mexico, this bird does not breed in the area covered in this book but is a regular migrant in both fall and spring. More individuals of this species are found in this three-state area during the fall migration window.

This is the tiniest of the U.S. hummingbirds. It has a thin, short bill, and males have a distinctive streaked gorget of rosy red. Even with their comparatively tiny size, females are difficult to identify because they have the standard colors of many female hummingbirds—green above and white below. A buffy wash on the flanks is a useful field mark (resembling, however, females belonging to the genus *Selasphorus*). Female Calliopes also have a small white spot behind the eye and sometimes a thin white area between the eye and base of the bill. Females have a more finely speckled throat than other members in the genus. The folded wing tips in both sexes reach just beyond the tail's tip in a bird at rest.

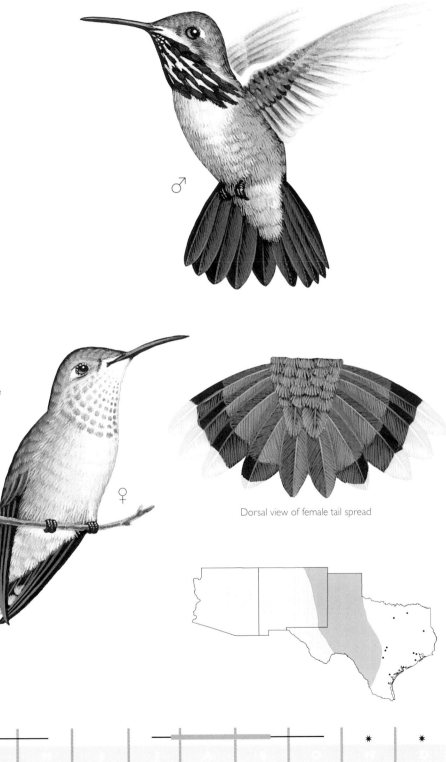

Dorsal view of female tail spread

Costa's Hummingbird *Calypte costae*

Female hummingbirds in the United States are almost always drab when compared to their male counterparts. If the plumage of the sexes of a given species is dissimilar, the species is considered sexually dimorphic. Needing to blend in while incubating eggs, as this female Costa's is doing, is a good reason not to be overly bright in coloration. Being cryptic is important for female hummingbirds, as they do all the rearing of the young.

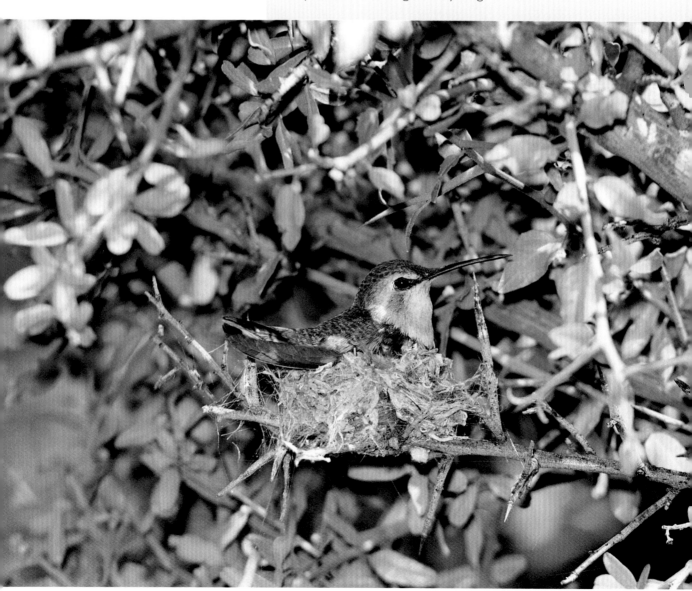

A tiny hummingbird found in arid areas, Costa's Hummingbird, like the Anna's Hummingbird, has a very restricted range. The Costa's occurs in the desert of the southwestern United States and northwestern Mexico, especially in the states of Baja California and Sonora. As of 2003, there were only twelve accepted records for Texas, a quarter of which were from El Paso County during the spring and winter months.

This hummingbird was named for a Sardinian amateur archaeologist and historian, best known for his military service but also for his library and museum work in history.

This bird has a short, slightly drooped bill and a short tail that does not project beyond the wing tips when the bird is perched. More than any other U.S. hummingbird, male Costa's have very iridescent gorgets and caps of extensive violet. This gorget extends to a point and moves with the bird like a stiff beard. Females are very difficult to identify, but on close inspection a decent field mark is the faint gray cheek patch and whitish eye line. Another good field mark for a perched bird of either sex is that the (long) wing tip reaches and sometimes barely surpasses the (short) tip of the tail.

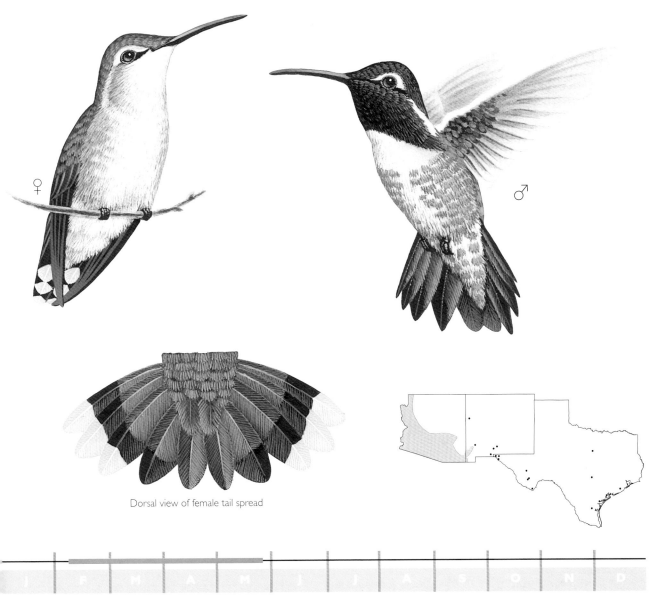

Dorsal view of female tail spread

The Green Violet-ear does not breed in the United States, but extralimital records occur at scattered locales across the eastern and central United States and southern Canada. The blue cheek patch and mostly glittery green body are its best field marks. The sexes in this species are nearly identical, with females being a tad duller than the males.

Green Violet-ear *Colibri thalassinus*

This Latin American species is not expected to be seen anywhere in the United States, but sightings have occurred as far north as Ontario, Canada, and some of the Great Lakes states. The bird is typically found in high mountain forests from central Mexico to central South America. For the area covered in this book, the violet-ear has been documented only in Texas, with over thirty-five accepted records. The majority of these records are from May, June, and July, but the extremes include early April through early October (no winter records). This species typically roams from higher-elevation breeding grounds to lower-elevation wintering grounds, which may help explain why wandering individuals appear in the United States.

Watch for a large-sized hummingbird with a relatively straight bill (can appear drooped). The darkish band near the base of the tail and the bluish purple cheek patch are its most identifiable features.

This adult male Green-breasted Mango was photographed at a feeder in Roatan, Honduras. Most U.S. records of this species have been immature birds, and the majority of records have come from Texas. Breeding populations of this mostly sedentary species occur in the southern part of the state of Tamaulipas, Mexico, just a few hundred miles south of Brownsville, Texas. To date, there are no records of this species in New Mexico or Arizona.

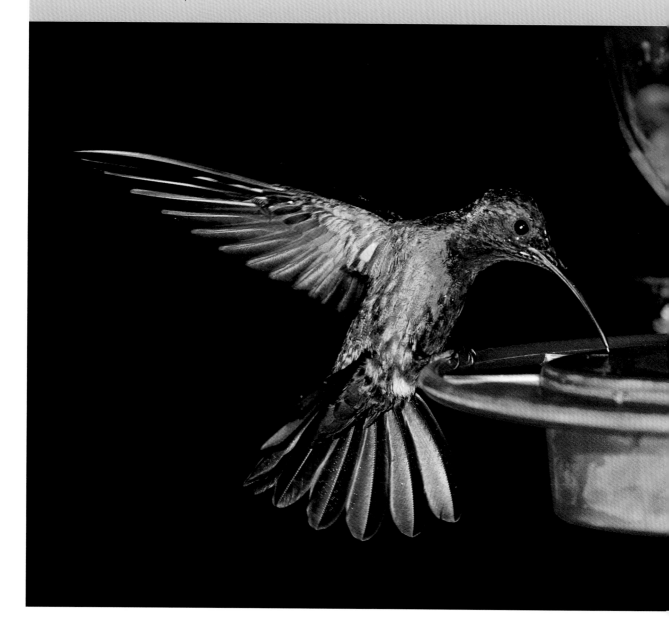

Green-breasted Mango *Anthracothorax prevostii*

Normally found from northeastern Mexico (southern Tamaulipas) to northern South America (Peru and Venezuela), this tropical hummingbird is known sometimes to wander widely. The first U.S. record was of a bird photographed in Brownsville, Texas, in 1988, and for some years, all U.S. records were from Texas. A well-documented individual appeared, amazingly, in North Carolina in 2000. By 2003, there was a total of twelve Texas records. Half of these come from August and September, with single records for the months of May, November, December, and January.

All but one U.S. record involve birds of immature plumage. No other U.S. hummingbird looks quite like an immature mango, with its thick stripes running down much of the length of the underparts. Among the several species of mangos, immature birds are very difficult to identify. But apparently, any individual with blue or green visible in the central breast stripe can be positively identified as a Green-breasted Mango; no other mango species has been recorded in the United States. This bird's bill is slightly, yet noticeably, decurved.

Few records exist in Texas for this nonmigratory species, which has a resident population occurring in southern Tamaulipas, Mexico, less than 250 miles from the Lower Rio Grande Valley. The lack of records is probably attributed to the bird's sedentary lifestyle (unlike the Green Violet-ear's highly mobile lifestyle, which has resulted in many more Texas records). Agricultural land that was once thorn-scrub forest in Tamaulipas also appears to have created an ecological barrier to the movement of this tropical species.

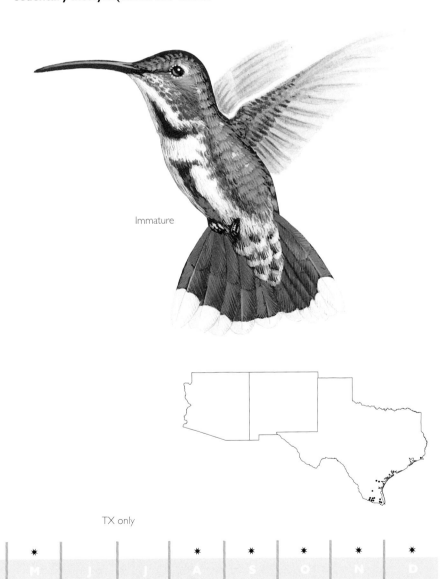

Immature

TX only

Lucifer Hummingbird *Calothorax lucifer*

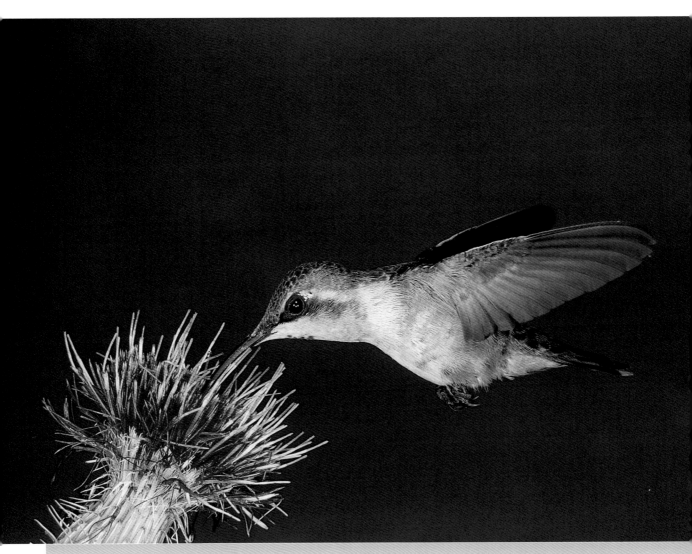

The female Lucifer Hummingbird has the same strongly decurved bill as the male and has rich buffy sides and a dusky face patch. In the United States, this species can be found mostly in arid lands of Big Bend, especially dry canyons where agaves flourish. The species is absent or rare during drought years when flowering plants are not available.

Despite popular belief, this bird is not named for the "Lord of Darkness." The name instead translates from the Latin as "bearer of light," a reference to the male's brilliant magenta gorget. This desert-inhabiting hummingbird breeds in the Trans-Pecos of Texas and small areas of southeastern Arizona and southwestern New Mexico. There are no confirmed winter records for any of these three states. Besides its small U.S. distribution, this near endemic to Mexico occurs almost to the Isthmus of Tehuantepec in southern Mexico.

Lucifer Hummingbirds are not expected to wander east of the Pecos River, but several records have been documented in the Texas Hill Country east to Bexar and Hays counties. Although they are typically found in elevations ranging from three thousand to seventy-five hundred feet on the breeding grounds, migrants and postbreeding wanderers can sometimes appear at lower elevations for brief periods. These hummingbirds feed on desert-blooming plants such

as agave and ocotillo, so the birds' occurrence can be as cyclical as the blossoming of these plants.

The best identifying features include the most strongly curved bill (in both sexes) of all U.S. hummingbirds and the forked tail of the male. The female has a pale buffy wash on much of the underparts, along with a dusky face patch that can be seen while the bird is perched.

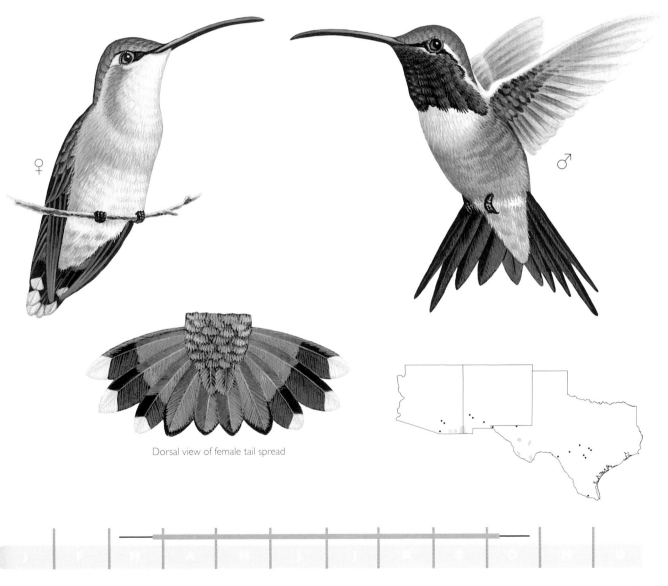

Dorsal view of female tail spread

Magnificent Hummingbird *Eugenes fulgens*

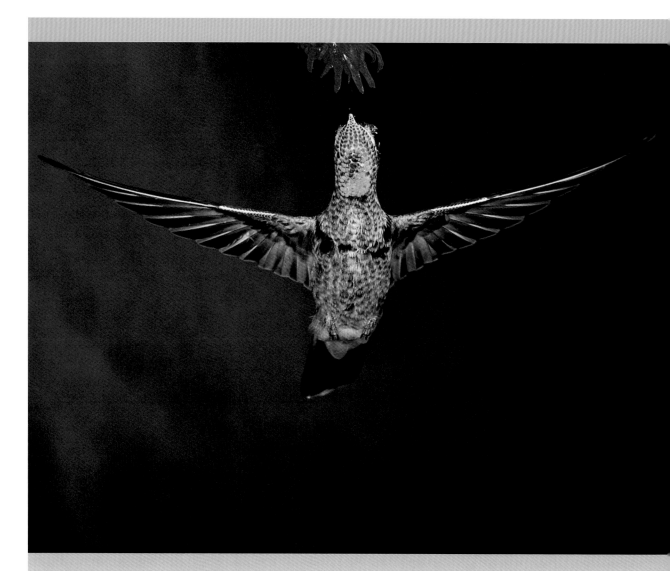

The green gorget is starting to develop on this immature male Magnificent Hummingbird. This might be the least nectar loving of U.S. hummingbirds, and it probably relies more on a diet consisting mainly of arthropods. Another unique feature of this species is that it does not defend a territory but instead wanders widely in a given area searching for food.

Formerly known as Rivoli's Hummingbird, this bird is truly magnificent in its large size and color, but then there is hardly a representative in the entire hummingbird family that is not magnificent. The Magnificent Hummingbird occurs in a variety of mountain forest habitats from the southern reaches of the three-state area to Panama.

The head of a male in good light displays amazing iridescent colors: a deep violet cap and a glittery green throat. A white spot behind the eye is quite noticeable as well. The remainder of the bird appears all dark in most lighting conditions. Females are far less colorful and strongly resemble the female Blue-throated Hummingbird. The main differences are that the Magnificent has much less white in the face, appears more flecked below, has smaller white patches in the tail when fanned, and has dark green upper tail feathers, not blackish blue ones.

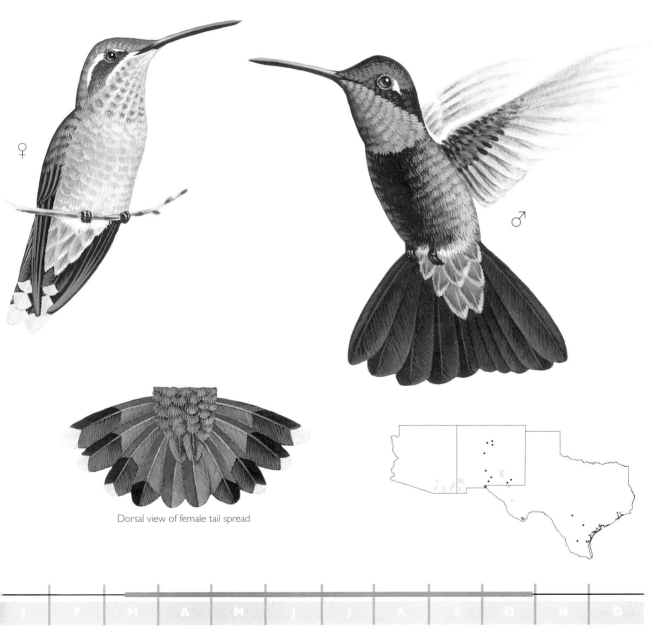

Dorsal view of female tail spread

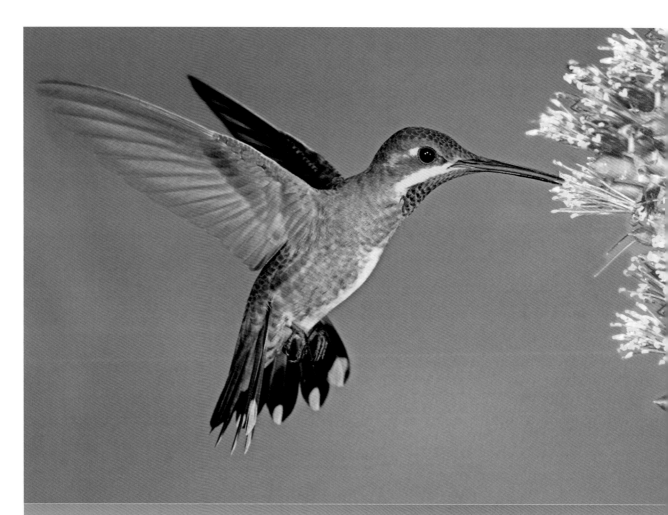

A bird mainly of the Pacific slope of Mexico south to Costa Rica, the Plain-capped Starthroat has never been documented in Texas but has been found in Arizona and New Mexico. This species rarely visits hummingbird feeders and seems to prefer feeding on arthropods instead. Watch for small patches of white on the body of this bird that help distinguish it from all other North American hummingbirds: white on the back and on the flanks (the latter sometimes seen only in flight). Photo by Anthony Mercieca / Anthony Mercieca Nature Photography

Plain-capped Starthroat _Heliomaster constantii_

This vagrant sometimes wanders into the lower elevations of southeastern Arizona and southwestern New Mexico during the summer months. The first U.S. record was not until September 1969 in Nogales, Arizona. In the United States, this species has been documented only in Arizona, with less than 25 accepted records. The Arizona Bird Records Committee includes it as a Review Species in that state (a species that requires documentation approved by committee before becoming an accepted record). There are two or three undocumented records for New Mexico. This is one of the few U.S. hummingbirds not yet recorded in Texas.

The Plain-capped Starthroat is a hummingbird with a very long bill and flashes of white in the face, tail, rump, and flanks on a predominantly dull, bronzy green and gray body. The sexes are nearly identical, and both have a gorget of metallic red in good lighting (otherwise, the color is "blacked out"). The female has a more extensive black chin and might appear less vibrant in the chin and throat, but this is very difficult to determine through binoculars.

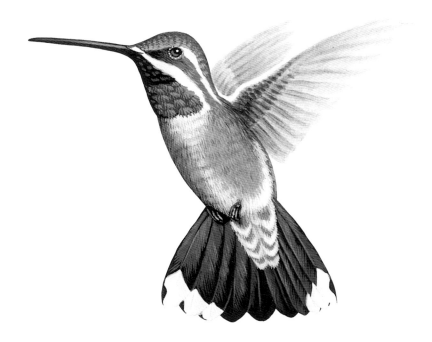

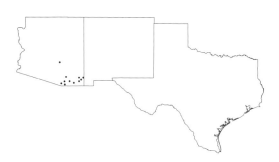

Southeast AZ only

Ruby-throated Hummingbird

Archilochus colubris

During the warmer months, this is the dominant hummingbird in the United States east of the Great Plains. Until the last few decades, the Ruby-throated was considered by most to be the only hummingbird in the eastern United States. A growing number of hummingbird feeders and observers, however, has revealed that it is not alone, especially along the Gulf Coast states in winter. There are only a handful of documented records of Ruby-throated Hummingbirds for New Mexico and none for Arizona. Most reports in those two states turn out to be misidentified Broad-tailed Hummingbirds. The Ruby-throated is highly migratory and able to make the five-hundred-to six-hundred-mile trip across the Gulf of Mexico nonstop. This species winters in Central America and extends as far south as Panama.

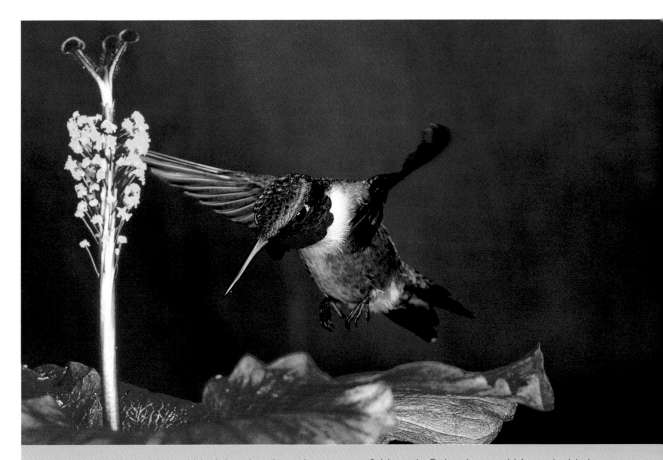

Notice the black chin and black border along the gorget of this male Ruby-throated Hummingbird feeding on a hibiscus. A trick among mountain hikers is to carry a red handkerchief so that during breaks the hanky can be tied to a limb nearby to attract roaming hummingbirds in the area. The red will attract them for a brief moment, but look quickly, because the bird will soon realize that there is no nectar reward.

Outside the mild **Gulf Coast** (especially southern Florida), there are very few winter records anywhere in the United States each year.

The female of this species is almost indistinguishable from the female Black-chinned; caution is advised when trying to identify one. The red gorget of the male seen at certain angles can appear completely blacked out, thus resulting in a speedy misidentification of a Black-chinned Hummingbird. At other angles, that same gorget can look fiery topaz (gold to orange). Carefully look for a more tapered wing tip on both sexes of a Ruby-throated at rest (versus a stoutly rounded wing tip of the **Black-chinned**), plus a slightly forked tail in a perched Ruby-throated male (versus a tail that is more squared in male Black-chinneds). The wings of both sexes of the Black-chinned in flight produce a low, soft whistling noise, whereas the Ruby-throated's wings produce a more faint and buzzy sound. One of the best behavioral differences between these two look-alikes is generally overlooked at the feeder or flower: Black-chinneds bob and flick their tails when hovering while feeding, but the Ruby-throateds keep their tails virtually motionless while hovering at a feeder or flower. This tail-flicking feature (or the lack thereof) does not apply away from active nectar feeding.

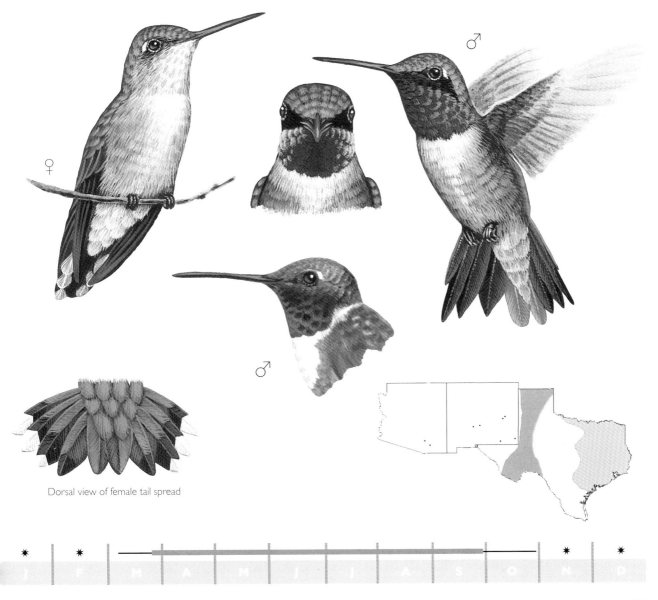

Dorsal view of female tail spread

Rufous Hummingbird *Selasphorus rufus*

A widespread western hummingbird, the Rufous Hummingbird has been showing up in just about any season except summer throughout the Gulf Coast states and to the Atlantic Coast. A hardy species, temperature-wise, it ranges to southern Alaska and is the most northerly occurring hummingbird in the Western Hemisphere. There is much debate over whether the species has adjusted its migratory patterns or whether more observers are detecting individuals

The gorget of this male Rufous Hummingbird glows like a brand-new, shiny penny amid the thistle patch. This wandering species has been documented in more states and provinces north of Mexico than any other species in the family.

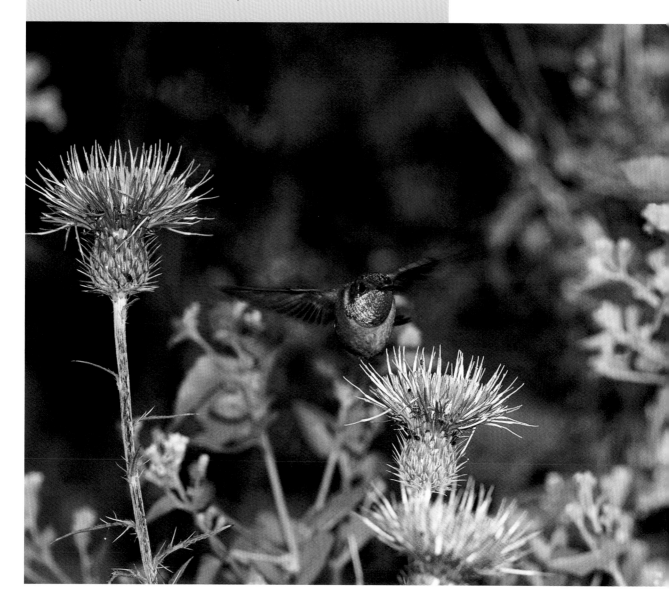

straying east instead of south for winter. At any event, this species can show up just about anywhere in the three-state area, a statement that could not have been made before the 1980s.

Like those of the Allen's Humming-bird, the underparts of the male of this species are bright orange and reminiscent of a brand-new, shiny penny. The gorget is a bright, glittery reddish orange or lime green depending on the lighting—a spectacular sight at any angle. The Rufous and the Allen's are likely the most misidentified hummingbirds in all the United States. Caution is advised when trying to identify the species (see more details in the Allen's species account). The upperparts are predominantly orange with a solid to nearly solid rufous back on most males (green flecks do appear on the backs of many males). Young males, however, sport a green back although elsewhere look like the adult, which is the reason it is commonly misidentified as the Allen's. This is one of the most aggressive among hummingbirds at feeders or flowers.

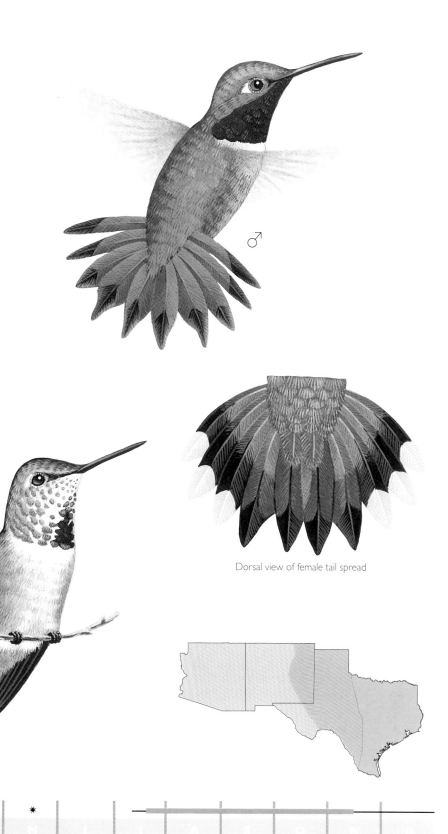

Dorsal view of female tail spread

Feathers must be in excellent shape in order for a bird to achieve flight. This preening adult Violet-crowned Hummingbird is a long hummingbird that has a bright red bill with a black tip. The most obvious field mark, unique among U.S. hummingbirds, is the snowy white underparts. The bird was named for its crown, which can appear purplish but at certain angles can also appear bright blue.

Violet-crowned Hummingbird *Amazilia violiceps*

A near-endemic species of western Mexico, this bird occasionally makes visits to the southeastern part of Arizona and the southwestern part of New Mexico. There are just a few documented records for Texas (only seven as of 2003) from scattered localities in the Trans-Pecos, the Lower Rio Grande Valley, and, astonishingly, from Lake Jackson on the upper Texas coast.

Unlike the sexes in most North American species, the sexes of this large hummingbird look alike, although the female tends to be a shade duller than her male counterpart—a trait that is difficult to judge in the field. The underparts are completely snow white (no dusky or buffy tints as in most females of other hummingbird species), which makes for a striking and unique field mark. The bright red bill with black tip, dingy brown upperparts, and purplish crown are useful features when making the identification. Although the Violet-crowned is almost identical to the Azure-crowned Hummingbird (*A. cyanocephala*) of northeastern Mexico, there are no U.S. records of the latter species.

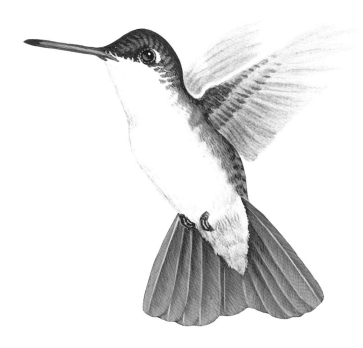

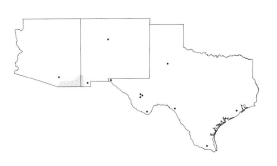

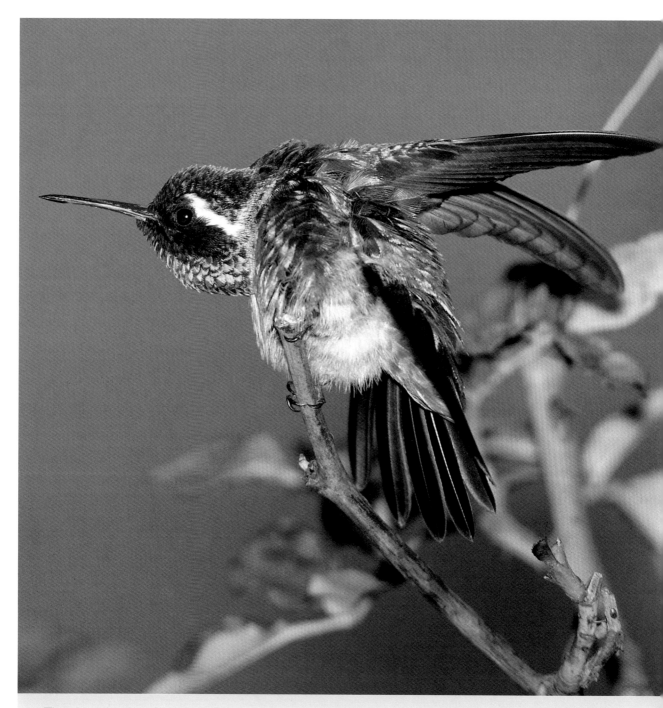

The abruptly steep forehead of this stretching male White-eared Hummingbird is very apparent here and a good field mark, even when the bird is silhouetted in a shadow. The short, straight, red bill and dark face with the broad characteristic "white ear" patch show up well when the bird comes out of the shadows into good lighting.

White-eared Hummingbird *Hylocharis leucotis*

A small, somewhat squatty-looking hummingbird found in coniferous forests of mountains and canyons from the Sierra Madre Occidental of northern Mexico south to Guatemala, this species barely makes an annual appearance in the southeastern parts of Arizona. There are scattered records for New Mexico and just over a dozen documented records in Texas, with most occurring in the summer months.

The fairly broad black-and-white face marks on both sexes are the best identifying features, in addition to the pointy crown on a mostly rounded head (not a crest). The bill of the male is fairly short, straight, and bright red with a black tip, whereas the bill of the female is similarly shaped but two-toned: blackish above and red below.

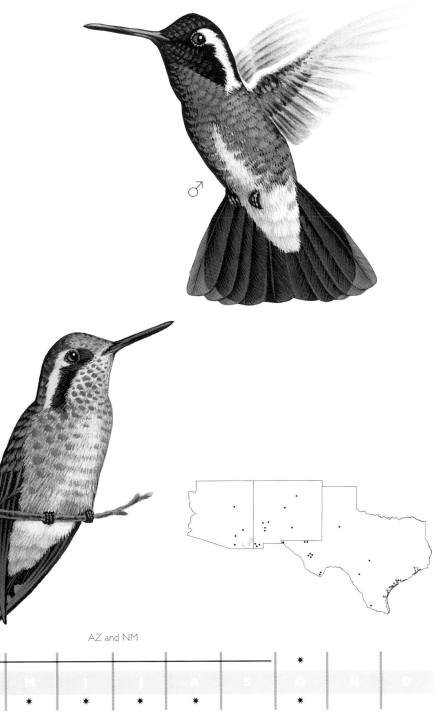

♂

♀

AZ and NM

| J | F | M | A | M | J | J | A | S | O | N | D |

TX

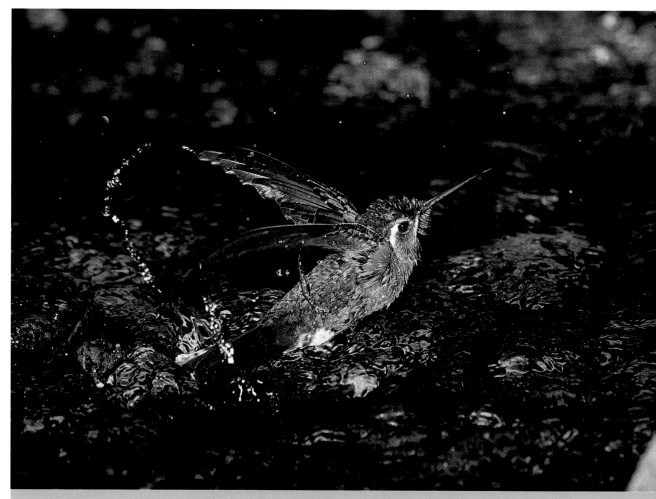

Because they prefer to stand while bathing, hummingbirds must bathe in very shallow water. In mountains, this might include bathing in the outer ripples of a fast-moving stream, as this male Blue-throated Hummingbird is doing in southeastern Arizona.

ndex

age numbers in *italics* refer to photographs.

gave, *38*, 44
lbinism, *28, 36*
llen's Hummingbird, 68, *70*, 71
methyst-throated Hummingbird, 68
nna's Hummingbird, *1, 6*, 22, *54*, 55, 57, *58*, 63, 68, *72, 73*
nts. *See* feeder pests
zure-crowned Hummingbird, 68, 105

athing, *108*
ats, *48*
ees. *See* feeder pests
erylline Hummingbird, 22, 41, 68, *74, 75*
ird banding, 18, 43
irdbath, *35*, 38. *See also* bathing
lack-chinned Hummingbird, *3, 6, 9, 14, 16*, 22, *28*, 29, *30, 31*, 40, 53, 68, *76, 77*
lue-throated Hummingbird, *11*, 37, 55, *59*, 68, *78, 79, 108*
ougainvillea, 38
road-billed Hummingbird, *7, 56*, 68, *80*, 81
road-tailed Hummingbird, 22, *23*, 31, *43, 48, 52*, 53, 57, *64*, 68, *82, 83*
rown, Dan. *See* Hummer House
uff-bellied Hummingbird, 27, 31, 41, 53, 57, 68, *84, 85*
umblebee Hummingbird, 68

Calliope Hummingbird, 22, *25*, 30, 53, 57, 68, *86, 87*
Canivet's (Fork-tailed) Emerald, 68
Cats. *See* predators
Cats Indoors! Campaign, 49
Cinnamon Hummingbird, 41, 68
circum-Gulf migrant. *See* migration
Costa's Hummingbird, *24*, 68, *88, 89*
cover, 37–39, *40*

Davis Mountains, 21, 22
Davis Mountains Hummingbird Festival, 22
discoveries and destinations, 20–22
drip fountains. *See* birdbath

feeder pests: birds, *50*, 51; insects, *16*, 45, 51
feeders, 38, 42, 46–47
Fennessey Ranch, 29, *30*, 31
firecracker fern plant, 16
flight, 40, 64
freeze, 55. *See also* overwintering hummingbirds

Great Texas Coastal Birding Trail, 31, 33
green anole (lizard), *50*
Green-breasted Mango, 68, *92, 93*
Green Violet-ear, 68, *90, 91*

hawking insects, 40
hibiscus, 37, *41, 42*
honeysuckle, 39, 44
Hooded Oriole, *50*
hovering. *See* flight
humans and hummingbirds, 12–18
Hummer/Bird Celebration, *12, 18*, 26, 26–27, *30, 31*
Hummer House, 28–29
hummingbird garden, 33–35, 37–39, *40, 42*
hummingbird spectacles, 26–27

iridescence, 65

lantana, 37, 39, 45
lemon mint, 37
Lucifer Hummingbird, *20*, 22, *65*, 68, *94, 95*

Magnificent Hummingbird, *19*, 22, 37, 55, 68, *96, 97*
Mexican heather, 51

migration, 27, 57, 66
mint, 37, 45
mister. *See* birdbath
molt, 24
morning glory, 38, 45

nearctic-neotropical migrant, 57
nests, *29*, 31, *59*

overwintering hummingbirds, 39, 52–56

pesticides, 50
photographing hummingbirds, 60–63
Plain-capped Starthroat, 68, *98, 99*
plants, 37–39, 40, 44–45. *See also* hummingbird garden; wildscapes
pollen (on a hummingbird), *43*
pollination, 38
polygamy, 25
praying mantis, *48*. *See also* feeder pests
predators, 16, 17, *48, 49*

ranch birding in Texas, 29–31
red food coloring, 38, 42, 47
roadrunner. *See* predators
Rockport-Fulton, Texas, 26, 27. *See also* Hummer/Bird Celebration
Ruby-throated Hummingbird, *6, 23*, 26, 27, 30, 31, *35, 42, 47*, 53, 57, 65, 68, *100*, 101
Rufous Hummingbird, *6, 17*, 22, 27, 30, 31, *38*, 40, 53, 55, 57, 60, 66, 68, 71, *102, 103*
Rufous-tailed Hummingbird, 85

salvia, 27, 37, 39
shrike. *See* predators
shrimp plant, 37, 44
sphinx moth, *51*
spiders and spider webs, 15. *See also* predators
sugar water ratio, 38

Texas Hummer Newsletter. *See* Texas Hummingbird Roundup

Texas Hummingbird Roundup, 13, 18, 22, 37, 53, 55

Texas Parks and Wildlife Department, 13, 18, 37

Texas Wildscapes, 39

thistle, *25, 37, 64*

torpor, 54, 55

trans-Gulf migrant. *See* migration

Treasures of the Trans-Pecos program, 18, 21, 22

tree tobacco, *8*, 37

trumpet creeper, 37, 39, 44

Turk's cap, 16, 27, 31, *35*, 37, 39, 45

vagrant, 41, 68

Violet-crowned Hummingbird, *15*, 39, 68, *104*, 105

wasps. *See* feeder pests

water sources. *See* birdbath

Wedge-tailed Sabrewing, 68

White-bellied Emerald, 68

White-eared Hummingbird, 22, 68, *106*, 107

wildscapes, *32, 34*, 55. *See also* hummingbird garden

window strikes, 49

wintering hummingbirds. *See* overwintering hummingbirds

Xantus's Hummingbird, 68

ISBN-13: 978-1-60344-110-0
ISBN-10: 1-60344-110-7